ART
IN MINUTES

Susie Hodge

ART
IN MINUTES

Susie Hodge

Quercus

Contents

Introduction 6
Ancient art 8
The Classical era 24
The Medieval period 44
The Renaissance 68
The Age of Discovery 120
The Enlightenment 172

The Industrial Revolution 200
Modernism 250
Space Age art 358
The Age of Information 384
Glossary 408
Index 412
Acknowledgements 416

Introduction

Humans have been making art for more than 30,000 years. Even before civilizations became established, paintings and sculpture were created, often showing remarkably advanced and sophisticated artistic skills. As societies evolved, materials, processes and techniques developed, and the art that was produced changed to suit new, changing lifestyles.

Over the centuries, art has been made by almost all societies. For ease of understanding, much of it is grouped into movements, schools, periods and styles, often retrospectively by art historians, or sometimes by the artists themselves. But not all of it can be categorized. The history of art is never regular or predictable, and it constantly changes. Rarely created in an isolated moment of inspiration, it is nearly always an amalgam of circumstances and experiences, feelings and opinions, social, environmental or political situations, or developments in technology, beliefs, traditions or thinking. It is also always about endeavour, ability, process and product.

Which is why it manifests in such a multitude of ways, and expresses anything from the universal to the commonplace.

Additionally, art has many functions. While much of it appears to have been created in imitation of the world, it is much more than that. It mirrors the times in which it has been made and, depending on the culture and location, can express and emphasize many different things, such as beauty, truth, death, order, immortality, power or harmony. As a form of communication or decoration, it can express philosophical points or religious beliefs, or it may simply entertain. Like another language, art becomes more fascinating when it is understood.

This book offers insights into a huge variety of art, from the earliest to the most recent. It's for anyone interested in art, from those who know a little, to those who know a lot. Roughly chronological, it considers many of the main developments in art throughout history and the world. In analyzing and appraising many inventions, ideas, materials and influences, backgrounds, skills, attitudes and approaches of groups of artists, skilled and talented individuals, and even those who produced just one ground-breaking work of art, the book interprets and explains over 30,000 years of art in minutes.

Stone Age sculpture

Long before humans invented writing, they created art. The oldest art so far found was made around 38,000 BCE, in the Stone Age Upper Palaeolithic period, and was probably connected to belief systems. Some of the earliest art was three-dimensional: small stone, ivory or bone female figures known as Venus figurines (although far predating the Roman myth) are the best known. Found in various parts of the world, they all share similar physical attributes, including short legs and arms and exaggerated breasts, bellies and thighs, suggesting that they may have been fertility icons. The most famous is the 11 cm (4¼ in) limestone *Venus of Willendorf* from Austria, made *c*.28,000–25,000 BCE.

As well as humans, Stone Age sculptors carved animals. South Korean figures carved on deer bone have been dated to around 38,000 BCE, and were probably good luck charms. The oldest known anthropomorphic carving is the *Lion Man of Hohlenstein Stadel* from Germany, a lion-headed human figure of similar age.

Stone Age painting

The first painters made images on rocks and cave walls using natural pigments, mixed with saliva or animal fat, and applied with fingers, sticks, moss or bones. The most famous are lifelike paintings of animals, including bison, horses and cattle. Sometimes natural variations on the walls were used to create three-dimensional effects. The inaccessibility of most of these caves suggest that they were not dwellings, but that the paintings were probably part of religious rituals, perhaps intended to evoke hunting success.

Despite the crude materials and the conditions in which they worked, many Palaeolithic artists demonstrate accomplished skills in rendering tone, movement and foreshortening. This is apparent at Lascaux in southwest France, where about 300 paintings and 1,500 engravings decorate two large caves c.17,300 years old. Similar images have been found in other caves across the world. Few realistic humans are depicted – instead, human presence often appears as hand prints.

Lascaux cave painting, *c.*17,300 BCE

Sumerian and Akkadian art

Often called the 'Cradle of Civilization', Mesopotamia comprised an area roughly corresponding to present-day Israel, Iraq, part of Iran, Jordan, Lebanon, Turkey and Syria, and flourished c.4,000–500 BCE. Neolithic cultures flourished here and it was the site of numerous inventions, including the first writing system, the wheel, the arch and the plough, and also saw the earliest implementations of law, medicine and science. Sophisticated irrigation systems also generated abundant harvests, leading to healthier populations.

The first Mesopotamian civilizations were the Sumerians and Akkadians. From c.4000 BCE, the Sumerians produced art that expressed their relationships with their gods and the natural world. In c.2300 BCE, they were conquered by the Akkadians. With slight differences, both civilizations produced ceramics, stone and clay statues, reliefs, steles and mosaics. Lifelike animal forms and human figures predominated. Fairly detailed, they are also rigid-looking, while figures and animals have large, expressive eyes.

Bust of Ebih-II,
c.2400 BCE

Babylonian and Assyrian art

The city of Babylon lay south of present-day Baghdad. During the Old Babylonian Kingdom (c.1894–1595 BCE) King Hammurapi (1792–50 BCE) defeated the other southern states and unified the former kingdoms of Sumer and Akkad. Sculpture predominated during this period. The New Babylonian Kingdom (627–539 BCE) achieved particular greatness in the reign of Nebuchadnezzar II (605–562 BCE). He rebuilt Babylon, surrounded it with massive walls and, c.575 BCE, built the huge Ishtar Gate, adorned with colourful reliefs of symbolic beasts, including bulls, lions and snake-dragons.

The Assyrians of northern Mesopotamia ruled c.2500–605 BCE, and were at their peak in the Neo-Assyrian period (883–612 BCE) when huge carvings of mythological Lamassu, or winged guardians, were installed in the palace of King Ashurnasirpal II (883–859 BCE) at Nimrud. They constructed lavish palaces and temples in different capitals, including Nimrud, Ninevah and Khorsabad, and filled them with monumental statues and reliefs, often glorifying the king, depicting battle scenes, grand banquets and people bearing gifts.

Lamassu figure from Khorsabad, *c.*710 BCE

Ancient Egyptian sculpture

From c.3,300–330 BCE, the ancient Egyptian civilization thrived along the River Nile. Throughout that time, its art hardly changed. Following major concerns about religion and death, it was distinctive and ordered, with everything following strict rules of representation. There was no place for individual artistic interpretation. Most Egyptian art was not meant to be seen by the living. It was mainly created to help the deceased nobility reach the afterlife, and despite the inflexible approach, figures had to look credible. Sculpted reliefs followed set formats, with buildings, animals, heads and limbs portrayed from the side, torsos and eyes from the front. Statues were also stylized: faces looked ahead, bodies were straight, and size was used to indicate status.

Materials used included sandstone, granite, alabaster, basalt, ivory and iron. Even mud from the River Nile was moulded, baked and glazed. Hard stone statues were polished with crushed sandstone; softer stone was covered in stucco and painted.

Pharaoh Menkaure flanked by Egyptian goddesses, *c.* 2500 BCE

Ancient Egyptian painting

As ancient Egyptian art was predominantly created to help the dead reach the afterlife, artists had to show the gods how the deceased had lived. Artists therefore did not try to replicate the real world, and no attempt was made to represent depth or texture. Like Egyptian sculpture, paintings had to be unambiguous, displaying the most representative aspects of everything. For instance, faces and limbs were shown in profile, eyes and shoulders from the front. Objects such as trees, boats and houses were depicted sideways on, rivers and fish from above. Differences in scale conveyed hierarchy; men were larger and darker-skinned than women.

Working methods were disciplined. Everything was planned on grids, colours were flat and bright. Pigments (mostly mineral) were chosen to withstand strong sunlight without fading. Paintings were created on tomb walls and papyrus. After *c.*1550 BCE, the *Book of the Dead*, an illustrated papyrus scroll buried with the dead, played a key role in transition to the afterlife.

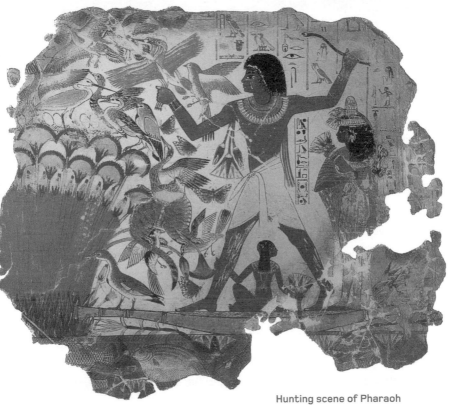

Hunting scene of Pharaoh
Nebamun, c.1350 BCE

Nefertiti, Tutankhamun and Ramses II

Three names are particularly associated with spectacular Egyptian art. Nefertiti was the Great Royal Wife of Akhenaten, the 'heretic' Pharaoh who promoted the worship of just one god and encouraged more realism in art. Her famous painted limestone bust, attributed to the sculptor Thutmose and made in 1345 BCE, features a stylized long slender neck, and subtle naturalism, including fine lines beneath her eyes. Akhenaten's son Tutankhamun ruled Egypt for just a decade until his early death aged 19. His tomb, discovered in 1922, contained many richly embellished artefacts. His solid gold mummy mask, inlaid with semi-precious stones, glass and faience, depicts him wearing a *nemes*, or head-cloth, adorned with the heads of a vulture and cobra – symbols of Upper and Lower Egypt. Its idealized face adheres to older Egyptian tradition.

About a century later, Ramses II (Ramesses the Great) built huge temples and palaces, illustrated his military victories on reliefs, and erected colossal statues of himself.

Thuthmose, Bust of Nefertiti, 1345 BCE

Early Chinese art

From c.1550 BCE, China experienced its first cultural Golden Age. The earliest Chinese writing was developed and organically-shaped bronze vessels were produced. Around 210 BCE, thousands of life-sized terracotta sculptures were buried with the First Emperor, Qin Shi Huang, to protect him in the afterlife. The greatest achievements came in the Tang Dynasty (618–906 CE), when both trade and art flourished. Often called the classical period of Chinese art, new palaces, temples, pagodas and tombs were built, and adorned with sculpture, paintings, carvings, textiles, glass and metalwork. Rather than realism, painters aimed to capture the spirit of their subjects. Through China's trading success, ideas were exchanged between countries. For the first time, painters created not only religious images, but also landscapes, known as *shan shui* ('mountain-water'), and scenes from history and court life. They focused on flowing lines to portray movement with delicate brush and ink work conveying atmosphere. Two of the most expressive were Wang Wei (699–759) and Wu Daozi (fl.710–760).

Terracotta warriors,
c.210 BCE

Minoan art

The Minoan civilization flourished on the Mediterranean island of Crete from *c*.2700–1450 BCE, developing a unique style of art. Named after the legendary King Minos, they cultivated a thriving trade around the Mediterranean, and built magnificent palaces. Their religion focused on female deities and officiators, and their frescoes differentiated genders by colour: men's skin is reddish-brown, while women are white.

In the Early Minoan (*c*.2700–2200 BCE), frescoes and ceramics featured flowing linear patterns including spirals, triangles, crosses and fish-bone motifs. In the Middle Minoan (up to 1500 BCE) vessels were usually made with the potter's wheel and often decorated with stylized marine creatures. By the Late Minoan (to 1000 BCE), vibrant flowers, plants, sea life and animals proliferated on pottery. Frescoes were painted while the plaster was still wet, so pigments adhered to the walls, and fluid brushstrokes and curving lines suggested movement. Soft stone carvings served both decorative and practical uses.

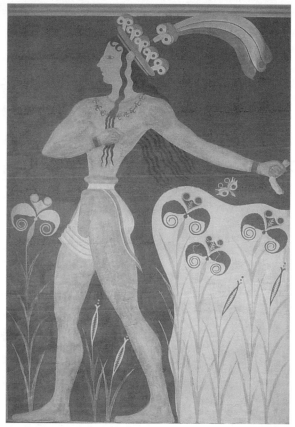

'Prince of the Lilies'
fresco from the palace
of Knossos, *c.*1550 BCE

Mycenaean and Greek geometric styles

The first high culture of the European mainland, the Mycenaeans arose c.2000 BCE. Greek-speaking, they were sophisticated and influenced by Minoan culture. This powerful, prosperous society produced a vast range of art and artefacts, such as pottery decorated with images of their warriors, gold funerary masks and other priceless objects that were buried with their dead rulers. They built bridges, fortifications, conical tombs and elaborate drainage and irrigation systems. Compared to the Minoans, their art is stiffer and more formal.

From c.900–700 BCE, the earliest Greek settlers produced art that was later termed the Geometric period. The population increased and art displayed geometric patterns and shapes, even in their alphabet. As worship became formalized, temples were built to house the statues of gods. The characteristics of this period are preserved in geometric monumental vases. The decorative theme of the meander, or key pattern, was a characteristic element of the time.

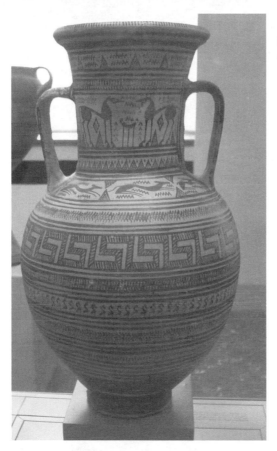

Late Geometric Attic
Amphora, c.720–700 BCE

Archaic Greece

The seventh century BCE saw the beginning of Greek art's Archaic period. Defined through pottery and sculpture, the period also saw the beginnings of democracy, and the re-establishment of written language. Influenced by neighbours such as the Egyptians, the Greeks adopted new styles that replaced the Geometric. The Archaic period (800–480 BCE) was more naturalistic. Paintings on vases represented human figures, often illustrating stories. In sculpture, faces were animated and bodies followed realistic proportions. The developing Doric and Ionic orders of architecture also reflected harmonious proportions.

The Archaic also saw developments in sculpture: using limestone, marble, terracotta, bronze and wood, sculptors created balanced figures, mainly to adorn temples and funerary monuments. Kouroi – life-sized or larger free-standing stone figures of unclothed young men striding forward – are one of the most distinctive products of the period. Korai are their clothed female equivalents.

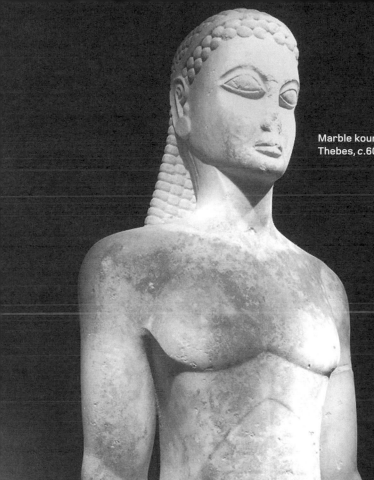

Marble kouros from
Thebes, *c.*600 BCE

Black- and red-figure pottery

Black-figure pottery is a style of Greek pottery painting that was common between the seventh and fifth centuries BCE. Artists painted or incised fine details with sharp implements onto red clay vessels, then painted them using clay, water and wood ash, leaving the background red. Artists fired the vessels in three stages, closing all the openings of the kiln. The lack of air made the pots turn black. When air was allowed in again, the painted parts remained black and the rest returned to red.

Around 510 BCE, red-figure pottery became more popular. It contrasted with the black-figure style as figures and shapes were the red of the clay, while backgrounds were painted black. These were created with the same method as black-figure pottery, only details were outlined in black using a fine brush rather than a sharp tool, making curves and details easier to apply. Patterns and pictures also contrasted more vividly against black backgrounds, so red-figure pottery was more expressive. Both styles depicted scenes from Greek mythology or daily life.

Red and black figure plates,
c.520–500 BCE

Classical Greek sculpture

During their Classical period, the Greeks achieved new heights in art, architecture, theatre and philosophy. The era began with a Greek victory over Persia in 480 BCE. Confident and with a new sense of unity among the city-states, artists began to try creating lifelike forms. The period became known as Greece's Golden Age. For the first time, artists observed and tried to replicate nature as realistically as possible. In sculpture, implied movement was introduced, as in *Discobolus*, a life-sized statue of an Olympic athlete by Myron, *c*.450 BCE.

Greek art reached a height of perfection during this period. A massive building programme began with the Parthenon, an imposing expression of harmony and balance, overseen by the sculptor Phidias. His style is characterized by a lightness of touch and attention to detail. Some of the greatest free-standing sculpture of the period was created by Polykleitos, a rival of Phidias. Praxiteles developed sculpture even further, skilfully expressing movement, balance, textures and emotion.

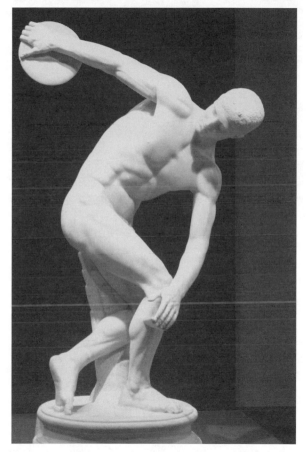

Roman copy of the
Discobolus of Myron
(original *c*.450 BCE)

Hellenistic sculpture

During the Hellenistic period that began under Alexander the Great (336–323 BCE), Greece transformed into a cosmopolitan culture spreading across the eastern Mediterranean and south-west Asia. Greek became the official language of the Hellenistic world, and the art and literature also changed: abandoning the previous preoccupation with idealism, Hellenistic art focused on realism, characterized by emotion and illusionistic effects.

While sculpture still depicted noble figures, naturalism spread to representations of common people, women, children and animals. Domestic scenes became acceptable subjects for reliefs. Realistic portraits of men and women were produced, and dynamic works including *The Dying Gaul* (*c*.220 BCE), the *Winged Victory of Samothrace* (*c*.195 BCE), *Laocoön and his Sons*, first century BCE, and *Aphrodite of Milos*, or *Venus de Milo*, *c*.130–100 BCE. All these statues depict Classical themes, but in more sensuous, naturalistic, theatrical and emotional representations than had been created in the Classical period.

Etruscan art

The Etruscans emerged in northern Italy c.700 BCE, between the Geometric and Archaic periods in Greece. Their origins are not clear, but they are thought to have come from Asia Minor, and were eventually assimilated into the Roman Republic in the late fourth century BCE. Etruscan art was strongly linked to religion. Attitudes towards death were similar to those of the Egyptians; they believed life continued after death, but unlike the Egyptians, saw their gods as hostile, and so created art to please them. Tomb walls were decorated with brightly painted murals in a free and fluid style, showing the lives of the (wealthy) deceased.

Although no architecture survives, clay models of Etruscan homes were made as funeral urns. Sarcophagi were also created, often with figures undertaking daily tasks. Figurative sculptures in terracotta and cast bronze display naturalistic gestures, but facial features and hair are rigidly stylized. Though in many ways it resembles the Greek Archaic style, Etruscan sculpture is neither as serene, nor as severe.

Sarcophagus of Seianti Hanunia Tlesnasa, c.145 BCE

Ancient Rome

The Roman Republic was established *c*.500 BCE, and the subsequent empire eventually stretched to Greece, western Europe, north Africa and parts of the Middle East. As a result, Roman art was an amalgam of styles from many cultures, particularly Greece. Much of it was created as propaganda – portrait busts were tributes to powerful figures. They were intended to look true to life, and included wrinkles, receding hairlines and sagging jowls. To commemorate victories, generals built triumphal arches and monuments. One of the best known is Trajan's Column in Rome, a spiralling monumental relief depicting the conquest of the Dacia in 101–106 CE.

Murals painted in the homes of the wealthy depicted naturalistic scenes of daily life. Artists intuitively expressed linear and aerial perspective to create illusions of three-dimensionality. They also produced wall and floor mosaics that were often realistic and portrayed movement, tonal contrast and expression. Monumental architecture was also embellished with statues and lively reliefs.

Bust of Augustus, first century CE

Fresco

From the Italian word for fresh, the term *fresco* describes a method of painting on freshly plastered walls. There are two methods: *buon fresco* and *fresco secco*. For both methods, fresh lime plaster is spread in thin layers over a wall and artists paint on the smooth surface. This final layer of smooth plaster is called the *intonaco*. Only small areas can be completed at a time, and one day's work is called a *giornata*. In *buon fresco*, artists paint on the wet intonaco, before the plaster has dried, which bonds the fresco to the wall. In fresco secco, artists paint on a dry intonaco.

Frescoes have been painted by artists at least since the Minoan period. One of the earliest known examples of *buon fresco* is *The Toreador*, or *Bull-Leaping*, made by the Minoans, c.1500 BCE in Knossos in Crete. Ancient Egyptian wall paintings were usually made using the fresco secco technique. However, the technique was at its peak during the Italian Renaissance, in works such as Michelangelo's Sistine Chapel ceiling of 1508–12.

Michelangelo, detail from *Creation of the Sun and Moon,* 1511

Mosaic

Mosaic is the art of creating images from small pieces of stone, coloured glass or other materials stuck to wet plaster. The pieces are usually small, flat and roughly square and called *tesserae*, but sometime floor mosaics are made of small rounded pieces of stone, called pebble mosaics. The earliest known mosaics are from the second half of the third millennium BCE, in a temple building in Abra, Mesopotamia.

Accomplished Greek mosaicists created detailed pictures with geometric borders, often illustrating mythological subjects or hunting scenes. The Romans enthusiastically adopted them, initially using Greek artists. Their two favoured techniques were *opus vermiculatum*, which used tiny tesserae allowing for fine details and tonal contrasts, and the more common *opus tessellatum*, which used larger tesserae. By the first century CE, Roman mosaics reached a peak. At first, black and white patterns were the most common, but by the second century CE, colourful expressive images became more popular.

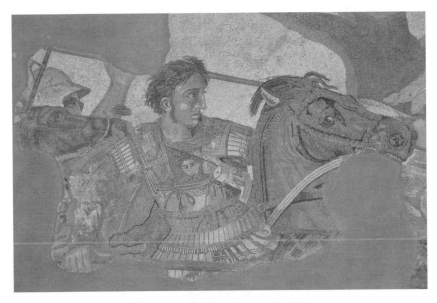

'Alexander Mosaic' from Pompeii, *c.*100 BCE

Early Christian art

By 313 CE, Christianity had become so powerful that Emperor Constantine (c.272–337) converted on his deathbed. By 380, it was the official religion of the Roman Empire, but by then the Empire had split; the West was still ruled from Rome, but the centre of power had shifted to Byzantium, now renamed Constantinople. Expressed in frescoes, mosaics, sculpture and manuscript illumination, the religion's first art almost exclusively portrayed Bible stories. Some second-century wall and ceiling paintings in the Roman catacombs (underground burial chambers) are the earliest identifiably Christian art.

A great deal of early Christian art borrowed from pagan Roman traditions and styles, which in turn had developed from Greek pagan art. During the third and fourth centuries, Christian figures were manifestations of earlier pagan models. For instance, early images of Jesus follow the Greek representations of Apollo. Gradually the art developed its own identity, since unlike much Greek art, its ideal was not physical beauty but spiritual feeling.

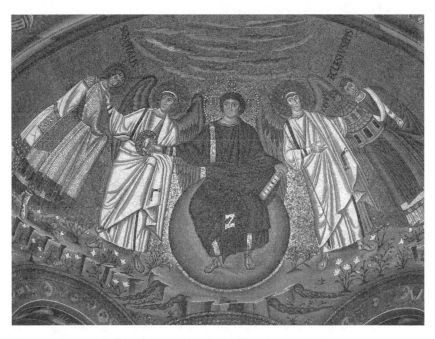

Ceiling of the San Vitale Basilica, Ravenna, 547 CE

Byzantine art

After Constantine transferred the main capital of his Empire from Rome to Byzantium (renamed Constantinople), a new style of art developed, lasting from c.330–1453. Byzantine images and icons derived from elements of Greek, Roman and Egyptian art, and appeared in Constantinople, Ravenna, Venice, Sicily, Greece and Russia. Concerned with religious expression, a strong sense of order dominates the art. The first examples appear in mosaics and frescoes decorating domed churches that were built in great proportions to express the omnipresence of God. Encaustic wooden panel paintings were produced in monasteries. More decorative than lifelike, flat, stylized images of holy figures predominated, often featuring symbolism. Sculpture was mostly limited to small relief carvings in ivory, usually for book covers, reliquary boxes and similar holy objects, but embroidery, metal- and enamel-work flourished. Although aspects of Byzantine art changed over time, it remained roughly consistent, its artists anonymous. In fact, religious imagery itself became so venerated that its use was opposed by some Eastern Church authorities.

Mosaic of Christ Pantocrator in the Hagia Sophia, Istanbul, c.1261

Icons

Icons, from the Greek word *eikones*, are sacred images representing holy figures, usually Christian saints and biblical characters. Byzantine icons appeared in painting, sculpture and mosaics, and ranged in size from miniature to monumental. Small icons were often used for private prayer, while large icons adorned churches, helping congregations to focus on worship.

In Byzantine theology, contemplation of icons enabled viewers to make contact with the figures represented, so that personal prayers could reach them directly. Symbolism, including objects, methods of representation and colour were important. For instance, gold represented the radiance of Heaven and blue symbolized life. Icons were intended more as religious objects than works of beauty, but this caused problems when viewers came to believe the sacred figures were actually present in the art. In *c.*726, the Eastern Church banned their use completely. Often called the 'First Iconoclasm', the ban lasted until 787, and the 'Second Iconoclasm' occurred between 814–842.

Icon of Our Lady of Kazan, Moscow (19th century reproduction)

Celtic and Viking art

The most powerful art in the British Isles from 500–1000 CE was Celtic. The Celts were tribes who originated in central Europe in the sixth century BCE and gradually migrated to Britain. As the Romans never conquered Ireland or Scotland, Celtic art flourished there. Based on semi-abstract designs, it manifested in metalwork, stonework and illuminated manuscripts, such as the Lindisfarne Gospels (c.650–750) and the Book of Kells (c.800). Rich and elaborate decorations follow colourful, intricate patterns, including tracery, spirals, steps and knotwork.

Viking or Norse art, produced in the British Isles and Iceland during the 8th to 11th centuries CE, manifested in swirling and interlaced patterns and abstracted animals on brooches, weapons, tools and ships. Influences can be seen from Celtic, Romanesque and Eastern European art. Viking craftsmen excelled in woodwork and metalwork, and as they often moved around, much of the art is portable and is generally more functional and symbolic than expressive.

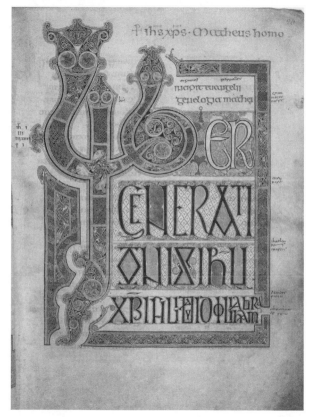

Page from the
Lindisfarne Gospels,
*c.*700 CE

Carolingian Renaissance

After being crowned Holy Roman Emperor in 800, the French king Charlemagne (768–814) gathered scholars to his court, aiming to revive the glory of the Roman Empire in his lands. He extended his territory from Italy to the North Sea and from the Elbe River to the English Channel, seeking to unite its population under Christianity. Newly commissioned translations of the Bible were illuminated in colourful manuscripts. Influenced by early Christian, Byzantine, Greek and Roman art, but modified by new ideas, these included the Lorsch Gospels and the Utrecht Psalter.

Charlemagne's revival of Christian art became called the Carolingian Renaissance. His enthusiastic patronage attracted some of the most significant intellectuals and artists of the time to his court. The influence of Roman and Byzantine architecture can be seen in Carolingian buildings, particularly the Palatine Chapel built for Charlemagne's court at Aachen in western Germany. Similar influences can be seen in the detailed and intensely coloured mosaics and manuscript covers.

Lothair Crystal, *c.*860 CE

Ottonian art

Following Charlemagne's death, internal and external conflicts threatened the existence of the Holy Roman Empire. It was divided on several occasions, but consolidated again under various rulers. The most significant of these were three German emperors, each named Otto, who succeeded each other in what is now called the Ottonian period (c.951–1024). Under the reigns of Otto I, Otto II and Otto III, the Holy Roman Empire was revived, with a different geography and character. In many ways, the art produced was a continuation of Carolingian art.

Ottonian art was created in the Low Countries, northern Italy and eastern France. Coinciding with a period of Church reform, it fused ideas and traditions from Carolingian and Byzantine art, blended with northern European traditions. Illuminated manuscripts, metalwork, wall paintings and luxury objects for churches and treasuries expressed grandeur, with Christian iconography predominating. It was less sophisticated than Carolingian art, but also intense and vibrant.

*Christ receiving the Magdeburg cathedral
from Emperor Otto I, c.965* CE

Early Islamic art

The Muslim era began officially in 622 CE, the year of the prophet Muhammad's flight from Mecca to Medina. Islam spread quickly throughout the Mediterranean, Asia and parts of Africa. As Arab culture spread, indigenous artistic traditions were absorbed, and Muslim art developed as an amalgamation of various styles. Under the Umayyad Dynasty (661–750), magnificent mosaic-embellished architecture was constructed, including the Dome of the Rock in Jerusalem in 691. The decorative arts continued to flourish under the Abbasid Dynasty (750–1258) notably in glassware, pottery, metalwork and textiles, featuring bright colours and 'arabesques;' rhythmic patterns resembling plant tendrils. Many shapes and patterns have symbolic significance. Although Muhammad's teaching does not ban representational art, the Qur'an states that there 'is nothing like a likeness of Him', resulting in the Islamic tradition of not depicting people or animals, although there are some exceptions. As the Qur'an is central to the art, calligraphy has always been an essential aspect, as have geometry, spirituality and a sense of rhythm.

Dome of the Rock,
Jerusalem, 689–91 CE

Central and South America

The first civilizations of central and southern America began to emerge around 2600 BCE. First established *c*.1400 BCE, the Olmecs wrote in hieroglyphics and developed a sophisticated style of stone sculpture. They are most famous for their mysterious, monumental 3-metre (9-ft) stone male heads with fleshy cheeks and flat noses. The Maya built most of their cities between 200–900 CE, and adorned them with paintings, carvings, ceramics, figurines and clay and stucco models. Most art, featuring flat, stylized imagery and hieroglyphs, was commissioned by kings.

Emerging in *c*.1200 CE in the mountains of Peru, the Inca civilization standardized religious art so it could be replicated across their empire. Simple geometric forms and stylized animals appeared in ceramics, wood carvings, textiles and metalwork. The Aztecs, meanwhile, emerged in *c*.1325 CE in Mexico. Their art developed from a mix of influences and beliefs, including the Olmecs, who inspired monumental stone sculpture. They also adorned their architecture, pottery and metalwork with figures, animals, plants and gods.

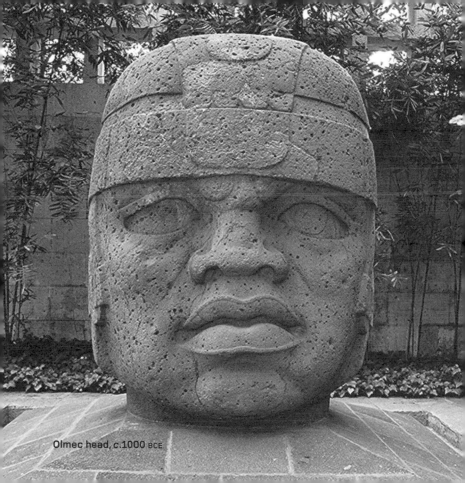

Olmec head, *c.*1000 BCE

Buddhist art

After renouncing a life of luxury, replacing it with good thoughts, and achieving nirvana or enlightenment, Siddhartha Gautama (c.563–483 BCE) became the founder of Buddhism. After his death, his teaching spread across Asia from his birthplace in northern India. The earliest Buddhist art represented the Buddha's presence by a sign such as a pair of footprints, or an empty space beneath a parasol. In the first century CE, human representations became more common, but his appearance differed in different places, in paintings and stone or stucco statues. Some Buddhas with wavy curls and draped clothing resembled Roman statues of Apollo, others were plump and jolly.

Particular themes also appeared frequently, including events from Buddha's life, and from his previous lives (of which there were believed to be 550). Some time between the fourth and sixth centuries, an 'ideal image' of the Buddha was created in northern India, achieved by combining elements from different locations.

Buddha in Cambodian Phnom style, c.17th century

Romanesque art

Following the collapse of the Roman Empire in Italy in the fifth century CE, western Europe experienced a long period of turmoil. The Roman Catholic Church was the only unifying force, and monasteries, especially the new Cistercian and Cluniac orders that developed in France, needed new buildings, books and Bibles. Large churches were built to accommodate priests and monks, and to welcome pilgrims who came to view saints' relics. Statues, reliefs, stained glass windows and wall paintings portrayed Christian doctrine to instruct illiterate churchgoers.

Romanesque art refers to a fusion of Roman, Carolingian, Ottonian, Byzantine and local Germanic elements, generally on a grander scale and more flamboyant than Early Christian art. Roman architectural features in its churches included rounded arches, barrel vaults and apses. This was one of the first times that individual artists and architects became known and sought after. The style peaked between 1075 and 1125, predominantly in France, Italy, Britain and the German lands.

Figures on the portico of the Cathedral of Santiago de Compostela, Spain, c.1180

Gothic art

The term 'Gothic art' originated among historians who believed that the Goths had been responsible for the styles of the period. As Goths were barbarian tribes, 'Gothic' was used in a disparaging sense. Developing from Romanesque, its styles grew out of architecture, which developed between c.1100 and 1500 as a means of glorifying God. As the European feudal system became more organized, a new, wealthy middle class began to expand. The first universities were established, and the mood across Europe was hopeful.

Gothic art primarily aimed to teach the illiterate about Christianity and inspire them with God's grandeur. With tall spires, flying buttresses and pointed arches, churches were built to point up at heaven, and their ornamental interiors were bathed in coloured light from huge stained glass windows (as at Chartres Cathedral). Originating in France and then spreading across Europe, Gothic art was expressed in panel paintings, frescoes, illuminated manuscripts, statues, stained glass and tapestries.

Portail royal of Chartres Cathedral, mid–12th century

International Gothic

From the late 14th to the mid-15th century, the Gothic style became increasingly decorative and courtly. Art historians later called it 'International Gothic' to differentiate it from the earlier style and establish it as a precursor of Renaissance art. Primarily practised at royal courts in France, England, Italy and Bohemia, the style soon spread across western Europe. Artists created portable works such as illuminated manuscripts, which they took to different European royal courts.

Artists associated with the style include sculptors Andre Beauneveu (c.1335–1400) and Claus Sluter (c.1340–1406), woodcarvers Veit Stoss (1450–1533) and Tilman Riemenschneider; and the painters Gentile da Fabriano (c.1370–1427) and the Limbourg Brothers: Herman, Paul and Johan (fl.1385–1416). These brothers produced the best known illuminated manuscript of the time: the *Très Riches Heures du Duc de Berry*. Common characteristics of International Gothic include the use of gold, rich embellishments and colours, and elegant, graceful and rather contrived figures.

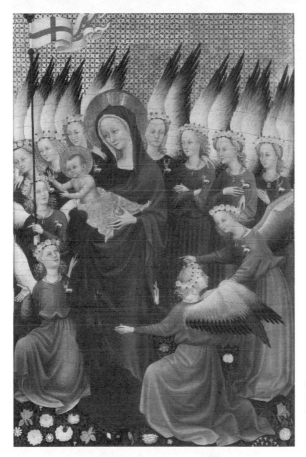

Detail from the
Wilton Diptych,
c.1390

Pre-Renaissance

From c.1290, the Pre-Renaissance began in northern Italy. Painters such as Antonio Pisanello (1394–1455), Giotto di Bondone, Cimabue (c.1240–1302) and Duccio di Buoninsegna (c.1257–c.1318) were highly influential – Duccio, for instance, ran a workshop that shaped generations of Sienese artists. He blended traditions of Byzantine art with elements of International Gothic, resulting in an expressive use of colour and pattern.

Pre-Renaissance art appeared on frescoes, panel painting, illuminated manuscripts, reliefs, statues and metalwork. Certain Italian regions, including Siena, Florence, Genoa, Venice, Milan and Savoy, were becoming more prosperous through trade, and the merchant families and dukes who ruled them were keen to make an impression by sponsoring art. Although Pre-Renaissance art was still religious, it was less stylized and more realistic than its precursors. Yet anatomical proportions and perspective were not important considerations – the focus was more on the spirituality of religious figures than on their physical appearance.

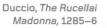
Duccio, *The Rucellai Madonna*, 1285–6

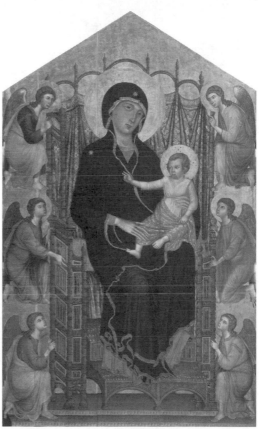

Giotto

The instigator of several Renaissance painting ideas, Giotto di Bondone (c.1266–1337) broke free from the static stylization of Byzantine art, introducing new ideals of naturalism and creating a convincing sense of pictorial space in his paintings. Mostly active in Florence, he also worked in Avignon, Padua and Naples. Giotto's main surviving fresco cycles are in the Arena Chapel in Padua, dating from c.1305. This series of 38 frescoes illustrates the lives of Christ and the Virgin, with varying emotions portrayed. In common with other artists of his day, he lacked technical knowledge of anatomy and perspective, but unlike any other medieval artist, he tried to make his figures look solid. Dramatic gestures emphasize emotion, while overlapping figures create impressions of space and depth. His *Lamentation of Christ*, c.1304–06, makes events credible by depicting the grief of biblical figures. In 1334, the city of Florence honoured Giotto with the title of *Magnus Magister* (Great Master), appointed him city architect and superintendent of public works, and invited him to design the new campanile of the cathedral.

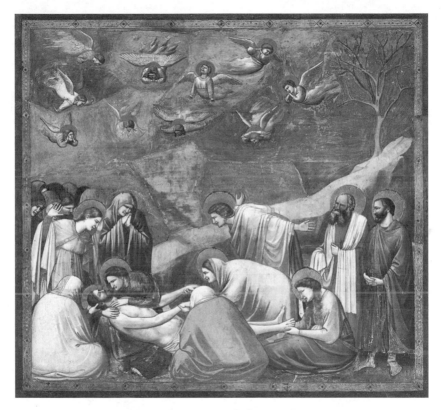

Giotto, *Lamentation of Christ*, c.1304–6

Early Renaissance

The Renaissance (French for rebirth) was a period – roughly from the 14th to the 16th century – that saw a rebirth of interest in the philosophy, literature, architecture and art of ancient Greece and Rome. Developments began in Florence and Siena when artists, scientists and philosophers rediscovered their past and simultaneously found individuality. Moving away from the notion of God's omnipresence, artists began to reflect a new interest in humanism. Related to this, they strove for accuracy, and no longer considered themselves to be anonymous craftsmen, but important, skilled individuals. Artists aimed to portray accurate proportions and lifelike human forms, clothing and expressions. In painting, figures appeared weightier, and the space they occupied was more convincingly constructed. New techniques suggested lifelike qualities, and after Florentine architect Filippo Brunelleschi (1377–1446) worked out a method of representing linear perspective on two-dimensional surfaces, flat paintings appeared particularly real. In sculpture, realism appeared in features, hair, clothing and gestures.

Masaccio, *Holy Trinity,*
c.1426

Masaccio and Donatello

One of the most revolutionary painters of the Early Renaissance, Tommaso di Ser Giovanni di Simone (1401–28), created a convincing sense of three-dimensionality. Better known as Masaccio (a nickname meaning clumsy or messy Tom) he was one of the first painters to use linear perspective. He discarded the ornamentation of the International Gothic and followed Giotto's method of using light and tone to create a sense of depth and solidity. Combined with his use of linear perspective, his works appeared astonishingly lifelike to contemporaries.

Masaccio was influenced by his friend Donatello, or Donato di Niccolò di Betto Bardi (c.1386–1466), who created statues and reliefs in marble, bronze and wood. Donatello learned his craft in the workshop of Lorenzo Ghiberti, the most important bronze sculptor of the time. A unique approach diffused his figures with emotion and dignity that echoed Greek Classicism. His bronze statue of David (c.1440s) was the first free-standing nude male sculpture created since antiquity. Shockingly, he was naked.

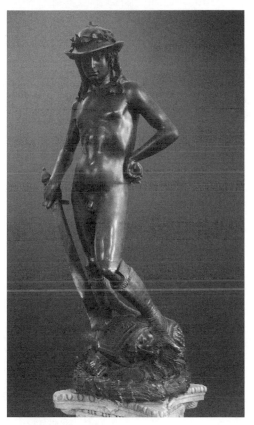

Donatello, *David,*
*c.*1440s

Perspective

Before the Renaissance, artists attempting to show distance on flat surfaces, simply made some objects smaller than others, with no uniform technique. But in the Early Renaissance, a mathematical method for creating the illusion of distance was rediscovered. 'Linear perspective' helped painters represent the world around them as realistically as possible. Lines converge to meet at a vanishing point on the horizon, and objects become smaller as they recede towards that point. Some images have more than one vanishing point, but the same rules apply.

Brunelleschi is believed to have worked out the method c.1410–15, after visiting Rome with Donatello a few years before. Its impact was immeasurable. In 1435, the artist Leon Battista Alberti (1404–72) wrote of perspective in his treatise, *On Painting*. According to art historian Giorgio Vasari, Paolo Uccello (1397–1475) stayed up all night working it out. Aerial perspective, meanwhile, is the atmospheric effect of distant objects appearing bluer and less distinct than closer objects.

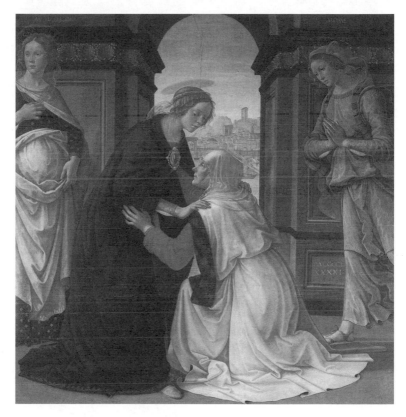

Ghirlandaio, *The Visitation*, 1491

The Gates of Paradise

The Renaissance developed initially in Florence, Italy. At the time, the city was ruled by the wealthy Medici family, powerful bankers who became great patrons of the arts, commissioning works from Florence's leading artists. Cosimo (1389–1464) and Lorenzo de' Medici (1449–92) were two of the most influential members of the dynasty, and helped to establish Florence as a cultural centre. Ideas and art that emerged there then spread to other parts of Italy and Europe.

In 1401, a competition was held to design two massive bronze doors for the Baptistery in Florence. Finalists included Lorenzo Ghiberti (1419–52), Brunelleschi, Donatello and Jacopo della Quercia (c.1374–1438). Ghiberti's was the winning design, and he completed the doors 21 years later. The 28 panels, mainly depicting the life of Christ, earned him a further commission to create two further doors, featuring Old Testament images across ten panels. All feature the principles of perspective, creating a sense of depth. Michelangelo later nicknamed the doors 'the Gates of Paradise.'

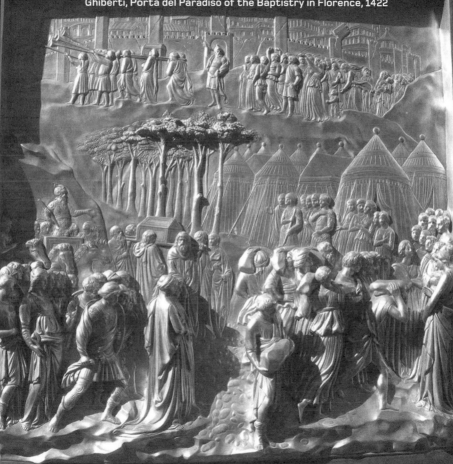

The flowering of Florence

Numerous Florentine artists in the Early Renaissance built on new ideas including the expression of emotion, humanism and the use of perspective. Among the most notable painters are Fra Angelico (born Guido di Pietro c.1395–1455), Fra Filippo Lippi (1406–69) and Benozzo Gozzoli (c.1421–97). The Dominican friar Fra Angelico painted harmonious depictions of biblical stories using clean lines and soft colours. From 1440 to 1443, he painted nearly 50 frescoes in the convent of San Marco in Florence, conveying spirituality and naturalism and using the principles of linear perspective. Famous for his affair with a nun and for being captured as a slave and gaining freedom by painting a portrait, Lippi's serene Madonna and Child paintings, and his richly coloured frescoes featuring numerous figures and strong tones, show the influence of both Masaccio and Donatello. A pupil and assistant of Fra Angelico, Gozzoli developed an ornate style, influenced by the International Gothic. He worked extensively for the Medici in Florence, and collaborated with Ghiberti. He also worked in Rome and Umbria.

Fra Angelico, *The Annunciation*, c.1442

Sacra conversazione

An Italian expression meaning holy conversation, sacra conversazione images became popular in the Renaissance, usually as altarpieces. They are paintings of the Madonna and Child with various saints, often from different historic periods, in a harmonious group around them. Settings are often architectural, occasionally in a garden or an open landscape, and most frequently using linear perspective to create the illusion of an extension to the chapel in which they were housed, suggesting the viewer was actually in the presence of the holy figures.

Most sacra conversaziones have pyramidal compositions, with the Virgin and Child at the top, set back on a throne. Although there is rarely an actual conversation going on, the saints are usually reading, meditating, looking at the Virgin and Child or out of the picture. Artists who produced particularly skilful and harmonious versions include Fra Angelico, Filippo Lippi, Piero della Francesca, Raphael, Giovanni Bellini, Paolo Veronese and Andrea Mantegna.

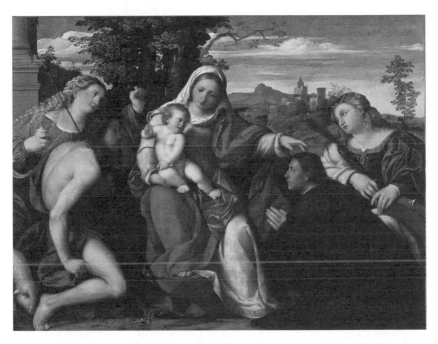

Palma Vecchio, *The Virgin and Child with Saints and a Donor*, c.1519

Middle Renaissance

As the 15th century progressed, innovative artists began producing increasingly skilful, lifelike works. The ideas that began in Florence spread across Italy as Florentine artists worked elsewhere and younger artists learned from them. Andrea del Verrocchio (c.1435–88) was the most important sculptor of the period, as well as a goldsmith and painter. His expressive, realistic details became legendary, and his pupils included Leonardo da Vinci and Sandro Botticelli.

Artist and mathematician Piero della Francesca (1419–52) made systematic studies of linear and aerial perspective. His shadows enhance depth and his compositions portray stillness. Andrea Mantegna (c.1431–1506) was also fascinated by perspective, using daring foreshortening with a powerful sculptural approach. His knowledge of Roman art is apparent in his dramatic, heavy-looking figures. Domenico Ghirlandaio (1449–94) was particularly skilful in the portrayal of contemporary figures within religious works. He led a large workshop whose most famous pupil was Michelangelo.

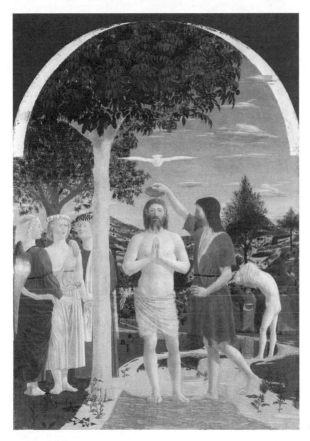

Piero,
The Baptism of Christ,
c.1450s

Botticelli

Following an apprenticeship as a goldsmith, Sandro Botticelli (c.1444–1510) studied painting with Lippi and Verrocchio. His graceful, ornamental and linear style relied on constructing compositions with line rather than tonal contrasts, a delicate approach echoing elements of Gothic art.

One of the first Renaissance painters to create large, elegant mythological and religious pictures, Botticelli's work reflected Lorenzo de' Medici's fascination with Neoplatonism and new ideas by the philosopher Marsilio Ficino (1433–99). *The Birth of Venus*, c.1482 and *La Primavera*, 1477–82, are filled with symbolism and scholarly ideas. His female figures are always similar – slender-bodied, with large eyes, somewhat melancholy expressions and flowing blonde hair – a look that was influential on Art Nouveau in the late 19th century. In later years, influenced by the Dominican friar Savonarola, he painted only religious works. Aside from two years in Rome painting the Sistine Chapel walls, he remained in Florence all his life.

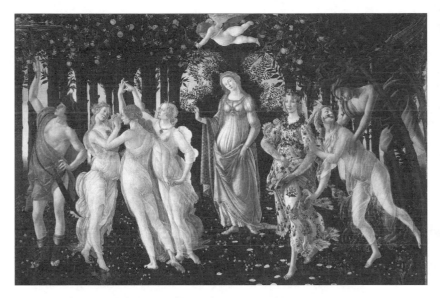

Botticelli, *La Primavera*, 1477–82

High Renaissance

As Renaissance ideas circulated across Europe, the period from the 1490s to 1527 later became known as the High Renaissance. The term was first used in the early 19th century to denote the period beginning around the time of Lorenzo de' Medici's death in 1492 and the unveiling of Leonardo da Vinci's fresco *The Last Supper* in 1498, and lasting until the sack of Rome by the troops of the Holy Roman Emperor Charles V in 1527.

This short period of exceptional artistic production occurred mainly in Italy, where painters and sculptors became ever more experimental and dexterous. Artists include Leonardo, Michelangelo and Raphael, plus Giorgione and Titian in Venice, and Dürer in Nuremberg, Germany. Patronage continued to come from the Church and wealthy individuals, and the emphasis on classical traditions and realistic, dynamic styles continued to be important. The art was complex and closely observed, reflecting new attitudes towards beauty and a sense of optimism. Painters abandoned tempera, preferring more forgiving oil paints.

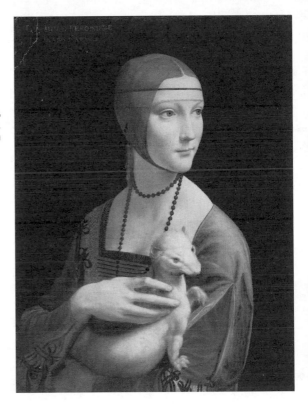

Leonardo,
The Lady with an Ermine,
c.1490

Leonardo

Painter, sculptor, inventor, engineer, scientist, architect, designer and musician, Leonardo da Vinci (1452–1519) was the archetypal 'Renaissance man'. Incessantly curious, he filled many notebooks with sketches, diagrams and mirror writing, as he worked out engineering, anatomical and artistic problems.

After training with Verrocchio, Leonardo worked as a painter in Florence, using cadavers to study human anatomy and proportion. Only about 17 paintings survive that have been attributed to him, but he also made many drawings. He painted using effects including soft tonal modulations, or *sfumato*, and portrayed reflective emotions and graceful poses. Fascinated by reading the 'motions of the soul' through expression and gesture, his works were enigmatic and alluring. Moving to Milan as an artist and military engineer for the ruling Sforza family, he painted *The Last Supper* for the refectory of Santa Maria della Grazie. He later worked in Rome, Bologna and Venice, and spent the last years of his life in France, a guest of King Francis I.

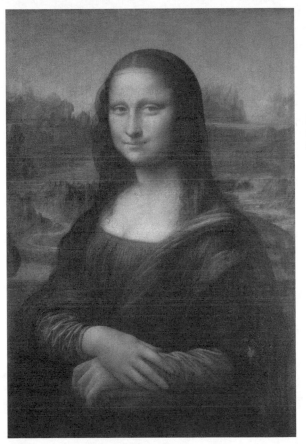

Leonardo,
The Mona Lisa,
c.1505

Michelangelo

Sculptor, painter, architect and poet, Michelangelo di Lodovico Buonarroti (1475–1564) was apprenticed to Ghirlandaio, then trained as a sculptor under the patronage of Lorenzo de' Medici. He first worked in Florence, Bologna and then Rome, where he carved the lifelike, emotive *Pietà* – the grieving Virgin Mary holding her dead son – from a single piece of marble.

From 1501 in Florence, among other projects, he produced the 4.3-metre (14.2-ft) statue of the biblical King David that became a symbol of the city. In 1505, he returned once more to Rome to create a tomb for Pope Julius II, a project that stopped and started until 1545. From 1508 to 1512, he painted over 300 life-sized figures in complex, dynamic poses and exuberant colour on the ceiling of the Sistine Chapel, portraying scenes of the Old Testament. Among many other commissions, in 1546, he was made chief architect of St Peter's Basilica. Nicknamed 'Il Divino' ('the Divine One') for his artistic genius, he was the first Western artist to have a biography published during his lifetime.

Michelangelo,
Pietà, 1498–9

Raphael

Like Leonardo and Michelangelo, Raphael (1483–1520) is one of an elite group of artists recognized by just his first name. For over 500 years his art has been considered by many as the embodiment of classical harmony. During his short life he was hugely productive, running an extremely large workshop and becoming the favoured painter and architect at the papal court.

Born Raffaello Sanzio in Urbino, Italy, Raphael learned painting techniques and humanistic principles from his father, Giovanni Santi, painter for the Duke of Urbino, and from Perugino. His lyrical and sculptural style pioneered a more human approach to devotional images – tender Madonna and Child groups were among the first paintings of the subject to display such lifelike and vulnerable gestures and expressions. Whether Bible stories, myths or portraits, he injected a sense of beauty and realism into all his work. From 1504 to 1507, he worked in Florence, then from 1509 to 1511 in Rome, where he painted Vatican frescoes including *The School of Athens*. In 1514, he became the Pope's chief architect.

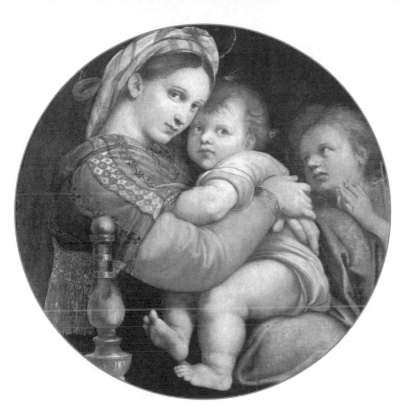

Raphael, *The Madonna of the Chair*, 1513–4

Myths and legends

For centuries, artists in many different societies have been commissioned to depict stories involving strong emotions and clear relationships to enlighten viewers. The ancient Greeks invented stories to venerate their gods. Similarly, from the fourth century CE, when Christianity became the main religion in Europe, artists were employed to translate the Bible into images to inform the populace and teach the illiterate.

Western painting developed through Church sponsorship, yet by c.1482, much art began once again to convey the things that Christianity had kept suppressed: the legends and myths of the pagan world. This was all part of Renaissance learning and humanism: as the philosophy and science of the ancient Greeks and Romans were rediscovered, so too were the myths. Once again, artists began interpreting stories in their own individual ways, and mythology soon became an excuse for artists in the Renaissance and later to paint with a flexibility and freedom of expression that was usually limited in Christian images.

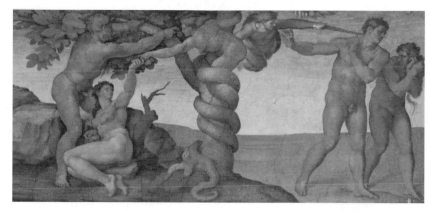

Michelangelo, *Adam and Eve* from the Sistine Chapel ceiling, *c.*1510

Venetian School

In the late 15th century, Giovanni Bellini (*c*.1430–1516) began a strong tradition of painting in Venice, with lucid and brilliantly coloured altarpieces and small devotional works. Influenced by his brother-in-law Mantegna, in turn Bellini inspired his pupils, particularly Giorgione (*c*.1477/8–1510) and Titian. Thanks to the vivid pigments available in Venice, colour predominated Venetian paintings. Almost nothing is known of Giorgione's short life, and only six or seven paintings can be definitively attributed to him, but he worked with Titian on several projects, and his small paintings are mysterious and dreamlike.

Working in Venice for a large part of his career, Sebastiano del Piombo (1485–1587) captured the harmonious qualities of Bellini and Giorgione, and the rich colours of Veronese and Titian. Paolo Caliari, known as Paolo Veronese (1528–88), was born in Verona but lived in Venice for most of his life. Famous for large narrative paintings, he is categorized with Titian and Tintoretto as one of the 'great trio' of Venetian High Renaissance artists.

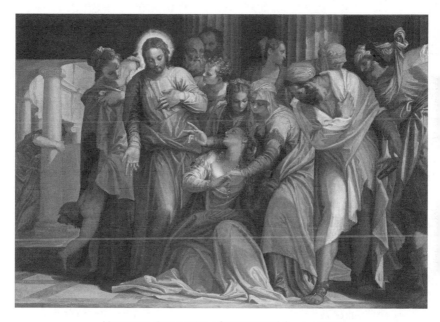

Veronese, *Conversion of Mary Magdalene*, c.1548

Titian

The leading Venetian painter of the 16th century, Tiziano Vecelli, or Titian (c.1489–1576), became the official painter of the Venetian Republic in 1516. Renowned for powerful portraits conveying sitters' personalities, he also painted religious and mythological works filled with exuberant energy and sumptuous colour. Bellini's influence can be seen in his radiant palette and balanced compositions, while Giorgione inspired his early style.

Titian's paint application and use of colour had a huge influence on younger artists. Although his style changed during a long career, his unprecedented loose brushwork and subtlety of tonal contrast endured. In great demand, he also worked for the Dukes of Ferrara, Mantua and Urbino. After meeting the Holy Roman Emperor Charles V in Bologna in 1530, he became principal painter to the imperial court, and later to Charles's son, Philip II of Spain. From the late 1550s, Titian applied freer brushwork and fewer details, and by the late 1560s, his loose style appeared to be moving towards abstraction.

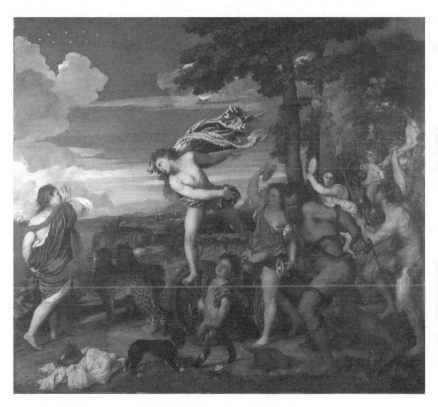

Titian, *Bacchus and Ariadne*, 1520–3

Northern Renaissance

While Italian artists embraced ideals of classical art and humanism, in northern Europe their counterparts were more influenced by Gothic art. Fresco did not flourish, and artists began using oil paint rather than tempera. Ideas were exchanged through trade and the invention of the printing press in c.1439 by Johannes Gutenberg (c.1398–1468) enabled books to be mass-produced, forever changing the structure of society.

Change was also driven by revolt. In 1517, German theologian Martin Luther (1483–1546) criticized the Catholic Church, triggering the Protestant Reformation that flourished in northern Europe. Protestant artists made Christian subjects more temporal, often in contemporary domestic settings. Figures were depicted from life, many images included symbolic meanings, and all were meticulously rendered. Exceptionally skilful Northern Renaissance artists included Albrecht Dürer, Jan van Eyck, Rogier van der Weyden, Robert Campin (c.1375–1444), also known as the Master of Flémalle, Hans Memling, Matthias Grünewald and Hugo van der Goes (c.1435–82).

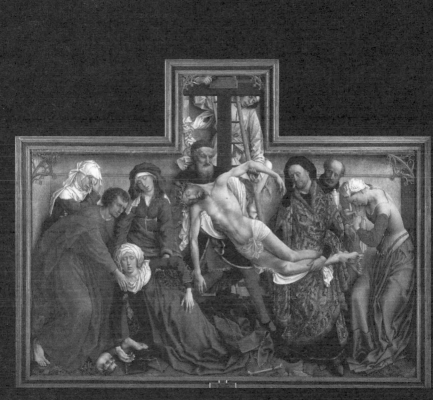

Van der Weyden, *The Descent from the Cross*, c.1435

Tempera and oil paints

Made from powdered pigment mixed with egg yolk, tempera was used for ancient and medieval paintings and for a large part of the Italian Renaissance. As it could not be stored and dried rapidly, artists had to mix small amounts and paint small areas at a time. The stiff consistency made blending difficult, and artists painted in layers. Then in the Low Countries during the 15th century, painters became more interested in describing the world around them in realistic detail and they discovered that mixing pigment with linseed or poppy oil rather than egg was more forgiving. Oil paint dried more slowly than tempera, so it could be pushed around and blended easily. It could also be applied in glazes or thin layers, and by creating brilliant colours, tonal contrasts, and a translucent sheen, it proved excellent for the depiction of a host of different textures.

As artists travelled between the Netherlands and southern Europe, the techniques of oil painting spread, and by the 16th century it was the major painting medium throughout Europe.

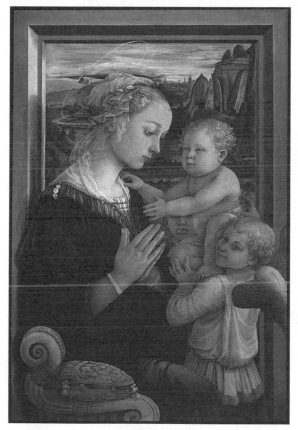

Fra Lippi, *Madonna and Child with Angels* (tempera on panel), c.1455

Van Eyck

One of the first Flemish artists to sign his name on his work, Jan van Eyck (c.1390–1441) was also one of the first artists to use oil paints. Applying thin, translucent glazes with almost imperceptible brushmarks, he achieved an extraordinary level of detail in portraits and religious paintings. Little is known of his origins, but he was from a family of painters and probably came from Maaseik, near Maastricht. By c.1422, he was working in the Hague, already a master painter with a workshop and assistants. Three years later, he was in Bruges and Lille, painting for the Duke of Burgundy. He undertook diplomatic visits, including to Lisbon in 1428 to paint the portrait of the Duke's future wife.

Admired for his accuracy, clear colours and sharp observations, van Eyck worked for private patrons as well as at court. One of his most famous paintings is the 1434 *Arnolfini Portrait* – a vivid double portrait filled with symbolism. He made great impact on Italian Renaissance art and his precise style and techniques influenced northern European art for centuries.

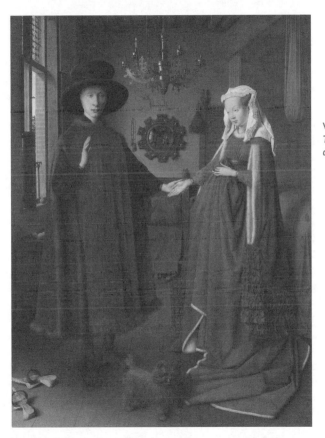

Van Eyck,
The Arnolfini Portrait,
c.1434

Van der Weyden, Bosch and Bruegel the Elder

With the exception of van Eyck, Rogier van der Weyden (c.1400–64) was the most influential painter of his day, famed internationally for his naturalism, detail and expression. In 1435, he was made painter to the city of Brussels, but he also painted for the Church and the rulers of Burgundy, Ferrara and Florence.

Hieronymus Bosch (c.1450–1516) became extremely popular for his large, fantastic landscapes that graphically illustrated moral and religious concepts. Little is known about his life, but he was born Jeroen van Aken in Hertogenbosch in the Netherlands. His paintings are explicit renditions of contemporary concerns, particularly related to human morality.

One of the greatest 16th-century northern artists, Pieter Bruegel (c.1525–69) pioneered genre painting. A highly educated Flemish painter and printmaker, he became known for his landscapes and satirical peasant scenes full of anecdotal detail. His expressive, witty focus on the poor was unusual in art.

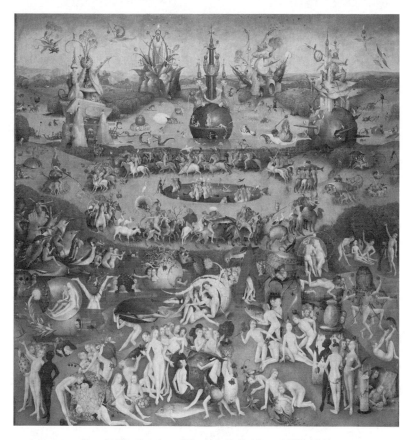

Bosch, *The Garden of Earthly Delights*, c.1490–1510

Memling, Riemenschneider and Altdorfer

Hans Memling (c.1430–94) was a German-born painter who became one of the leading artists in Bruges, known for his restrained and pious paintings. He spent time in Rogier van der Weyden's workshop and, in 1464, was made a citizen of Bruges. Retaining his early style, he painted numerous portraits, private devotional works and large religious paintings. Tilman Riemenschneider (c.1460–1531) was a German sculptor and woodcarver, active in Würzburg from 1483. Prolific and versatile, he was exceedingly skilled in working in sandstone, alabaster, marble and limewood. After he became a master sculptor in 1485, his workshop grew into one of the busiest in Germany.

German painter, engraver and architect, Albrecht Altdorfer (c.1480–1538) worked in Regensburg, Bavaria. Along with Lucas Cranach the Elder and Wolf Huber (c.1485–1553), he is considered a leader of the 'Danube School', a group who were among the first to paint pure landscapes and highly expressive figures, making a decisive break with the high finish of Northern Renaissance art.

Riemenschneider, *Rudolf von Scherenberg*, c.1495

Dürer

The greatest figure of Northern Renaissance art, Albrecht Dürer (1471–1528) was a German printmaker, painter and writer. The son of a Nuremberg goldsmith, he became the first artist to produce self-portraits at different stages of his life and one of the first to experiment with etching, raising woodcut and engraving techniques to new levels of artistry. He also travelled widely. In 1490, he visited Cologne and the Netherlands, and he established the practice of artists visiting Rome and Florence as part of their artistic education. In Venice, he met Bellini and saw the work of Mantegna and Antonio del Pollaiuolo (c.1432–98). He blended many Italian ideas with those of northern Europe.

Dürer's woodcuts are often called his 'master prints', and revolutionized the potential of the medium. Sold across Europe, they established his reputation and influence while he was still in his twenties. His vast body of work includes altarpieces, religious works, portraits and engravings, and he wrote treatises on principles of mathematics, perspective and proportion.

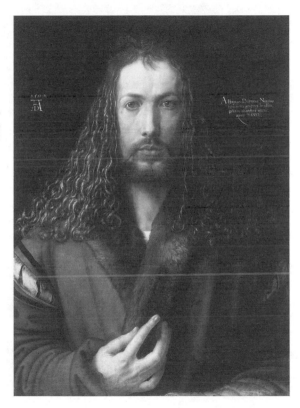

Dürer,
Self-portrait,
*c.*1500

Cranach, Grünewald and Holbein the Younger

The chief artist of the Reformation, Lucas Cranach the Elder (1472–1553) was the leading painter of Saxony, one of the most influential 16th-century German artists and a co-founder of the Danube School. Among his vast output, he produced altarpieces, portraits, hunting scenes and paintings of slender, elongated young women, both nude and fashionably dressed.

The colourful works of Matthias Grünewald (c.1475–1528) feature dazzling light effects. His current reputation is based mainly on his greatest masterpiece, *The Isenheim Altarpiece* (c.1514) filled with life, colour and tangible emotion. Although he was a Protestant, he also executed several commissions for the Catholic Church.

One of the most accomplished portraitists of the 16th century, painter and printmaker Hans Holbein the Younger (c.1497–1543) spent two spells in England, portraying figures at the Tudor court, often with numerous allegorical elements. Outstanding in capturing lifelike details, he also designed jewellery and metalwork.

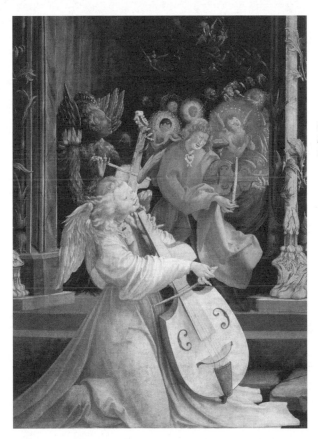

Grünewald,
Isenheim Altarpiece,
1512–6

Spanish Renaissance

During the 15th and 16th centuries, Italian Renaissance ideas spread to Spain, where great changes were occurring. From 1479 to 1504, Isabella of Castile and Ferdinand of Aragon jointly ruled the country and aimed to unify it under Roman Catholicism. They expelled Jews and Muslims (Moors) and set up a religious Inquisition to police heresy, but also sponsored Columbus's four voyages to the Americas.

Spanish Renaissance artists included Fernando Gallego (c.1440–1507) who painted in a dramatic, yet naturalistic manner, clearly influenced by Flemish painting. The Cretan-born painter, sculptor and architect El Greco (1541–1614) trained in icon painting and studied under Titian and moved to Spain in his mid-30s. His elongated, unnaturally coloured pictures blended ideas from Byzantine art, the Venetian Renaissance and Mannerism, illustrating the strict piety of the Counter-Reformation. With his precise style and warm colouring, Alonso Sánchez Coello (1531–88) was a pioneer of Spanish portrait painting.

El Greco, *The Vision of Saint John*, 1608–14

Art academies

Instigated from the ideas of art historian Giorgio Vasari (1511–74), and established by Cosimo I de' Medici, the first formal art academy began in Florence in 1563. The Accademia de Disegno aimed to arrange and promote exhibitions, organize art education and dictate artistic standards. Membership was considered exceptionally prestigious. A similar association, the Accademia di San Luca, was founded in 1577 in Rome, with the purpose of raising the status of painters, sculptors and architects above mere craftsmen.

The French Académie Royale de Peinture et de Sculpture was founded in Paris in 1648 and later became the Académie des Beaux-Arts. The Parisian Académie aimed to distinguish fine artists from craftsmen – the emphasis on the intellectual side of making art had an appreciable impact on the subjects and styles that became known as Academic art. After this, art academies began opening throughout Europe, imitating the teachings and styles of the French Académie.

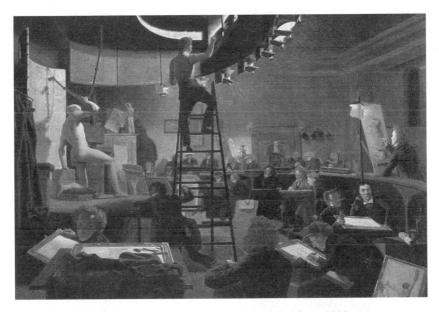

Bendz, *Life Class at the Copenhagen Academy*, 1826

Mannerist painting

As well as the Protestant Reformation causing massive upheavals across Europe, the 16th century saw outbreaks of plague and the Ottoman Turks attack Vienna. Many of the harmonious ideals of the Renaissance were abandoned, and numerous artists imitated Michelangelo's mature, gestural style, exaggerating figures, colours and compositions.

In the 20th century, the style was retrospectively labelled Mannerism. Jacopo Pontormo (1494–1557) painted sculptural figures, thrusting them towards the edges of his compositions. His pupil Angelo di Cosimo, or Bronzino (1503–72), worked as court painter to the Medici. His elegant paintings seem detached, while El Greco painted in a unique, darkly dramatic elongated style. Parmigianino (1503–40), an Italian painter and printmaker, created elongated, graceful images with unusual perspectives and deliberated poses. The Venetian Jacopo Robusti, better known as Tintoretto (1518–94), experimented with dynamic perspectives and unusual lighting to create energetic and lyrical pictures.

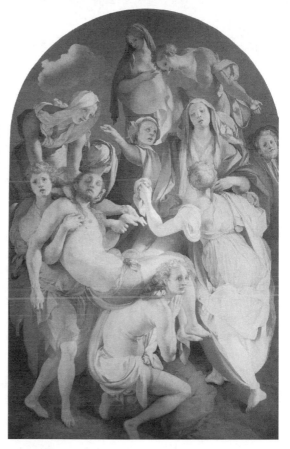

Pontormo,
*The Deposition
from the Cross*,
1525–8

Mannerist sculpture

In reaction to social, political and religious disruptions, sculptors also began exaggerating and distorting their images. Subjects were predominantly religious and mythological. Overall, Mannerist sculpture was thoughtful, spiritually intense and experimental. The greatest Mannerist sculptor was Flemish-born Jean de Bologne, who settled in Florence and became known as Giambologna (1529–1608). Extremely successful during his lifetime, he produced animated figures in marble and bronze, from miniature to monumental. His dynamic, complex and graceful figures often take poses described as *figura serpentinata* – a human figure twisting around a central core, in a coiling, contorted stance.

Benvenuto Cellini (1500–71), another important Mannerist, also lived and worked primarily in Florence until he was exiled for duelling. A sculptor, goldsmith, engraver, pupil of Michelangelo and author of a celebrated autobiography, he had many influential patrons, including Francis I and Cosimo de' Medici.

Giambologna,
Hercules and Nessus,
1599

Chinese Ming Dynasty

After nearly a century of Mongol rule, the indigenous Ming Dynasty took control of China in 1368 and helped the country rise once more as a great power. The Forbidden City was built in Beijing, and artists were commissioned to portray the dynasty's generosity and grandeur. Old traditions were revived, and new skills, techniques and styles developed.

Paintings were delicate, comprising landscapes and figurative narratives, while calligraphy became expressive and closely integrated with painting. Ceramics became more sophisticated, with blue and white ware and cloisonné inspired by Islamic art through China's flourishing trade links. A Bureau of Design maintained standards of decoration on ceramics, textiles and other objects. Individual painters were skilled in a range of techniques, but the Wu School of artists were particularly adept in the 'Three Perfections' of poetry, calligraphy and painting, led by Four Great Masters, Shen Zhou (1427–1509), Wen Zhengming (1470–1559), Tang Yin (1470–1524) and Qiu Ying (1494–1552).

Wen Zhengming, *Landscape of the Humble Administrator's Garden*, 1533

Japanese art

From the 14th to the late 16th century, Japan was ruled by shoguns from the Ashikaga family. Great patrons of art, they commissioned the building of many Zen temples, and under their rule, several art forms originated, including Noh (a form of musical drama), ink painting, garden design, flower arranging and the tea ceremony. Great artists of the period included Sesshū Tōyō (1420–1506), a master of ink and wash painting. Influenced by Chinese Song Dynasty landscape painting, he had a large following now known as the 'School of Sesshū'. Kanō Eitoku (1543–90) created expressive, large-scale landscapes, and Hasegawa Tōhaku (1539–1610) began painting Buddhist images, but after the 1580s, produced atmospheric paintings.

Most painting was executed in rapid brushstrokes with few details. By the late 14th century, monochrome landscapes (*sansui ga*) were fashionable. The Kanō School established by Kanō Masanobu (1434–1530) lasted to the 19th century, adopting Chinese painting style, with strong emphasis on brushwork, ink and natural subjects.

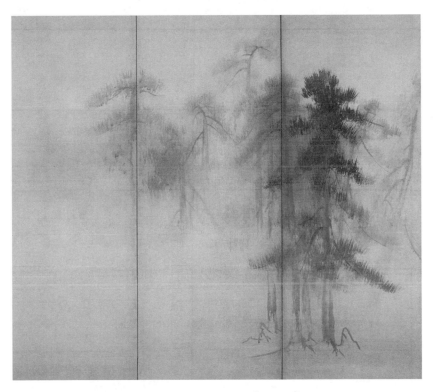

Hasegawa Tōhaku, *Pine Trees* (section), 1593

Ceramics

The word 'ceramics' comes from the Greek word *keramos* meaning 'potter's clay'. Most traditional ceramic products are made from clay, or clay mixed with other materials, which are then shaped and fired in an oven and usually coated with a glaze, made of minerals, to make them impermeable. Clay figurines have been found from *c.*24,000 years ago, and some form of ceramic art has arisen in almost all developed cultures.

Often, ceramic objects are all the artistic evidence left from vanished cultures such as the 2,000-year-old Nok objects from Africa. Cultures especially noted for their ceramics include Chinese, Cretan, Greek, Persian, Mayan and Japanese, as well as more modern societies. Ceramics are still made by contemporary artists such as Grayson Perry, who won the Turner Prize in 2003 for his brightly decorated vases. The potter's wheel was first used in the Middle East *c.*4000 BCE and was in common use by *c.*3000 BCE. It enabled artists to create smoother, thinner and more uniform ceramic objects.

Islamic tiling panel, late 16th century

The Counter-Reformation

Until the Reformation, the Roman Catholic Church had dominated western Europe for a thousand years. Starting in Germany, the ideas of Protestantism spread quickly throughout Europe, and traditions of Catholic art were rejected. In place of art that venerated Jesus, Mary and the saints, Protestants encouraged moralistic depictions of secular life that could not be mistaken for idolatry. Printmaking, which allowed images to be mass-produced at low cost, was also encouraged.

In response, between 1545 and 1563, the Catholic Church held the Council of Trent, resulting in a Counter-Reformation that aimed to revive Catholicism. One area of discussion considered how art in Catholic countries, especially Italy, currently emphasized ornament over religious subjects, and an edict was duly passed that art must be strictly religious. Certain subjects were given increased precedence, and as the Counter-Reformation gained strength and the Church felt less threatened, it used the arts as a way of articulating a message of Catholic dominance.

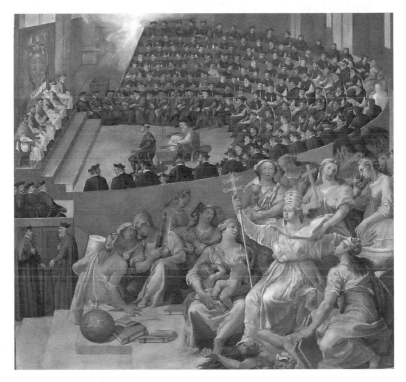

Pasquale Cati, *The Council of Trent*, 1588

Baroque in Italy

Following the Council of Trent, the Roman Catholic Church decreed that art should portray biblical truths, depicting subjects clearly, powerfully and with dignity, without the stylistic airs of Mannerism. The resulting art was extravagant, emotional and often featured dramatic contrasts of highlight and shadow.

Annibale Carracci (1560–1609), one of the first painters in a movement later named the Baroque, produced energetic, colourful works inspired by Titian and Veronese, with expressive brushstrokes and atmospheric light. Pietro da Cortona (1596–1669) produced large, busy scenes, while Guido Reni (1575–1642) and Domenichino (1581–1641), influenced by Raphael, both pursued a more classical approach, with richly coloured, idealized images. In an era that was difficult for female artists, Artemisia Gentileschi (1593–c.1656) painted pictures of powerful women from mythology and the Bible, creating strong tonal contrasts influenced by Caravaggio. Baroque sculptors included Gian Lorenzo Bernini and Alessandro Algardi (1598–1654).

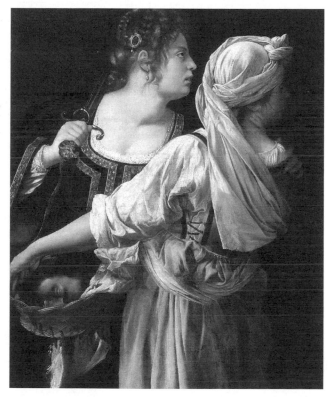

Gentileschi,
*Judith and her
maidservant*,
1612–3

Caravaggio

Among the most revolutionary artists of the Baroque, Michelangelo Merisi da Caravaggio (1571–1610) was born in Milan, and worked in Rome, Naples, Malta and Sicily. He quickly gained success with paintings that imparted spirituality and realism, and had a formative influence on Baroque painting in general. Yet his private life was controversial, involving murder and confrontation with the Church, and his work was also contentious. In contrast with the accepted idealization of sacred individuals, he depicted holy figures as peasants with dirty feet, fingernails and clothing – an approach perceived by many as sacrilegious. His works were particularly sensational for their detailed, natural realism, and the intense, revelatory moments portrayed. Unusual compositions, featuring foreshortening and heightened *chiaroscuro* (contrast between light and dark) created emotional tension. He worked at great speed, drawing directly onto his canvases with paint on his brush handle. His models included friends, prostitutes and peasants. After his life was cut short, his followers became known as Caravaggisti or Caravagesques.

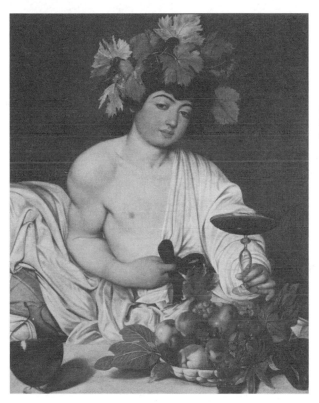

Caravaggio,
Bacchus,
c.1595

Chiaroscuro and tenebrism

From the Italian words *chiaro* and *scuro* meaning light and dark, chiaroscuro is a method of representing strongly contrasting tones. Leonardo used it to create compelling effects of light, and by the late 17th century, the term was used to describe any image that employed powerful extremes of light and dark. Caravaggio used the technique in a particularly dramatic way, darkening shadows and using vivid shafts of light to heighten emotional tension in his paintings, a style later called tenebrism, from the Italian word *tenebroso*, meaning murky.

After Caravaggio, Rembrandt van Rijn used chiaroscuro and tenebrism to create psychological effects. Others who used the techniques include Peter Paul Rubens and Diego Velázquez. By the 18th century, in reaction to the excessive drama of the Baroque, Rococo artists rejected the technique, but it was revived by many Romantic artists who followed. Chiaroscuro was also used fairly prominently in 16th-century Italian woodcuts, such as the work of Ugo da Carpi (c.1480–c.1526).

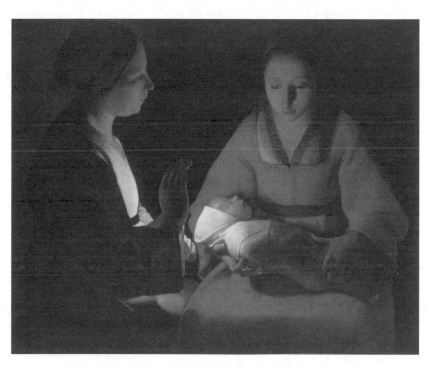

De La Tour, *The New Born*, c.1645

Bernini

A devout Roman Catholic, Gian Lorenzo Bernini (1598–1680) was an architect, painter, playwright, and costume and theatre designer, but predominantly the inventor of Baroque sculpture. Inspired by the notion of exalting God, he expressed the grandeur of the Baroque with extravagant theatricality, detail, sensitive interpretations of textures and portrayals of movement. His dynamic figures express palpable emotions, and his portraits also depict fleeting facial expressions with acute realism. He had the unique ability to make cold, hard marble look soft and warm.

During his long career, Bernini worked under successive popes and became a leading architect, working on St Peter's Basilica. His dramatic colonnade transformed the front courtyard of Rome's cathedral, and he was also responsible for town-planning schemes and instigated the extravagant Baroque fountains in several Roman piazzas. His reputation declined temporarily, after his bell towers for St Peter's began cracking in 1641, yet he is still acknowledged as the last of Italy's comprehensive geniuses.

Bernini,
Ecstasy of Saint Teresa,
1647–52

Baroque in France

During the 17th century, France began to challenge Italy for dominance in the visual arts. French Baroque art was more classical and sedate, and less overtly Catholic than the corresponding art in Italy. In 1627, Louis XIII summoned the French painter Simon Vouet (1590–1649) to his court from Italy where he had spent 14 successful years. Vouet brought with him the Baroque style, adapting it to suit Louis's lavish tastes. His pupil, Charles le Brun (1619–90), became the favourite artist of Louis XIV and director of the newly opened Académie Royale de Peinture et de Sculpture in 1648. His pupil, Hyacinthe Rigaud (1659–1743), became the quintessential Baroque portrait painter.

Well known for dignified paintings of peasant life were brothers Antoine (*c*.1588–1648), Louis (*c*.1600–48) and Mathieu (1607–77) Le Nain, who established a Paris workshop in 1630. Yet while Paris was the most important French art centre, it was not the only one: working in Lorraine, Georges de la Tour (1593–1652) became known for contemplative images, inspired by Caravaggio.

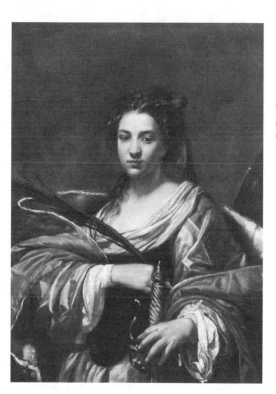

Vouet,
Saint Catherine of Alexandria,
date unknown

Poussin and Claude

French Baroque paintings also included landscapes: imaginary, tranquil scenes, often linked to mythological themes. The greatest French painter of the age, Nicolas Poussin (1594–1665), spent most of his career in Rome; his refined style was based on his admiration for classical culture, and his erudite and harmonious paintings express great literary and philosophical subjects. Unlike most of his contemporaries, he worked alone.

Claude Lorrain (1604–82), one of Poussin's few friends, became the most admired and influential landscape painter of the 17th century. His scenes are idealized, flawless visions, representing a dreamlike golden age of antiquity. Many are backlit, and they often include visionary ports, ships, ancient buildings and figures. With an exceptional command of colour, his delicate lighting effects maximize the poetic impact of his paintings, imbuing them with a timeless serenity. His work was particularly influential in Britain, for later landscape artists such as John Constable and J.M.W. Turner, and even for garden and park design.

Poussin, *The Shepherds of Arcadia*, 1637–8

Spanish Golden Age

The 17th century is often called the Spanish Golden Age, when the arts and literature flourished. Initially, Mannerism predominated, but soon artists began using rich colour and chiaroscuro and tenebrism to create a sense of drama.

Velázquez was the leading painter of the age, but others, such as Francisco de Zurbarán (1598–1664), were also highly admired. After spending time in Italy, José de Ribera (1591–1652) was particularly influenced by Caravaggio and took ideas of tenebrism back to Spain. Zurbarán also expressed strong chiaroscuro effects in religious paintings that include few background details and intense light and shade effects. Fray Juan Sánchez-Cotán (1560–1627) painted *bodegóns*, or still lifes, that are striking in their treatment of light, and Bartolomé Esteban Murillo (1617–82) also painted luminous effects in his religious works and paintings of contemporary women and children. Claudio Coello (*c*.1642–93) had a colourful, dramatic and dynamic style, influenced by both Velázquez and Titian.

Velázquez,
Pope Innocent X,
1650

Velázquez

One of the most influential painters in history and the pre-eminent artist of the Spanish Golden Age, Velázquez (1599–1660) had a realist approach with an added element of emotion in his portraits, and religious, mythological and historical subjects. He began his career producing *bodegóns* that show Caravaggio's influence, and his later work reveals great mastery of capturing light, atmosphere and colour, using unprecedented loose and fluid brushmarks, natural style and ease of manner.

At 24, he became court painter to Philip IV (1605–65) – the only artist allowed to paint the king. At court, he studied paintings in the royal collection and befriended Peter Paul Rubens when he was in Madrid in 1628. He also visited Italy to study the art and buy paintings for the king. Becoming close friends with the king and his family, he continued to rise up the ranks of the royal household. His last years were mostly taken up with royal portraits, and in 1658 he was made a Knight of Santiago, an honour he had always desired.

Velázquez, *Las Meninas*, 1656

Portraits

Before the invention of photography, painted, sculpted or drawn portraits were the only way to record appearances. From the Latin word *protrahere,* meaning 'to draw forth or bring to light', they have been made for thousands of years in a variety of media to show sitters' likenesses and character. They often show qualities such as power, influence, beauty, wealth or learning. Some of the earliest portraits were painted on wooden boards attached to Egyptian mummies from the early first century CE. Realistic portraits of important figures were also common in ancient Roman sculpture. Although most portraits have been of rulers, more recently 'ordinary' people have been represented. Fashions in portrait styles change. In the Early Renaissance, the classical profile view became customary, then the more complex three-quarter view, showing more of the face, became common, Probably the most famous portrait, Leonardo's *Mona Lisa,* conveys different aspects of the young woman's personality at once. Most portraits flatter their sitters, but some, such as Goya's portraits of the Spanish royal family, are candid and uncomplimentary.

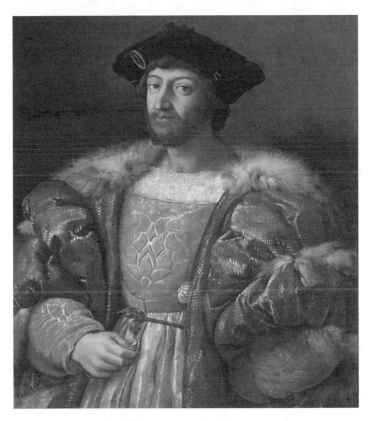

Raphael, *Lorenzo di Medici*, c.1519

Baroque in Flanders

Political and religious differences in northwestern Europe led to the formation of two independent states. Holland (the present-day Netherlands) broke from Spain at the end of the 16th century, while Flanders (modern Belgium and part of northern France) remained part of the Spanish Roman Catholic Empire into the 17th century.

Antwerp and Brussels became leading art centres, with religious subjects paramount. The art was vibrant and accomplished. Rubens exemplified the culture through his dynamic and exuberant Baroque style. His influence on Flemish art was huge, and many students trained at his busy studio, including Anthony van Dyck (1599–1641) who became Rubens's chief assistant while still a teenager. Van Dyck painted religious and mythological scenes, but was primarily a brilliant portraitist, in demand in European courts, and particularly in England. Jan Brueghel the Younger (1601–78) followed his father and painted landscapes, allegorical scenes and other subjects in meticulous detail.

Judith Leyster, *Young Flute Player*, c.1635

Rubens

The greatest Baroque painter and leading exponent of Catholic art in northern Europe, Peter Paul Rubens (1577–1640) created fluid, luminous works of great energy, inspired by Michelangelo, Tintoretto and Caravaggio, and infused with his own sensual vitality. His talents and interests made him one of the most versatile and prolific artists of the era, perfectly suited to the ostentatious tastes of the age, and the great demand for his work meant he had an exceptionally large and busy studio. During the Counter-Reformation, his innovations helped to define Antwerp as one of Europe's major artistic cities. Working in Italy from 1600 to 1608, Rubens studied classical antiquity, Renaissance art and contemporary work by painters such as Caravaggio. Whether in landscapes, portraits, allegories or religious stories, his work was vigorous, decorative and theatrical. He preferred smooth wood panels to canvas, and his inventive compositions featured colour contrasts, harmonies, textures and expressions of passion and joy. His female figures became known for their abundance of rosy flesh.

Rubens, *The Three Graces*, c.1635

The human figure

Since ancient times, portrayals of humans have been stylized or lifelike, but always important. Venus figurines are the earliest known representations of the human body, and many cultures have modelled their deities on the human form so viewers could identify with them. In cultures where figurative art is permissible, humans have been used to relate religious stories.

The figure has also been depicted in many cultures to explore issues such as identity, gender, race and social standing, or less tangible aspects such as belonging or love. Proportion has always been subjective, but for centuries, an essential part of art students' training has been life drawing, to ensure the correct depiction of anatomy. In the late 18th century, students in the studio of Jacques-Louis David spent about six hours each day drawing from a model who remained in the same pose for a week. Ideals of beauty vary with times and individuals. For instance, Rubens's voluptuous women contrast directly with the slender figures of Amedeo Modigliani.

Leonardo,
Vitruvian Man,
c.1490

Dutch Golden Age

After its independence in 1648, the Dutch Republic became one of the wealthiest and most powerful countries in the world, dominating international trade and creating a vast colonial empire. Merchants became wealthier, creating the first bourgeois society, and also the most religiously tolerant country in Europe. In such circumstances, great advancements were made in the arts and sciences. Many renowned painters, including Rembrandt and Vermeer, came to prominence.

With no church patronage, relatively few biblical paintings were produced. Instead, popular genres included scenes of peasant life, landscapes, townscapes, seascapes, flower paintings and still lifes. The idealization and splendour of Baroque art was absent. Most paintings were relatively small, with group portraits being an exception. Best known for these and his single portraits of the wealthy, Frans Hals (c.1582–1666) also painted scenes of daily life with wit and loose painterly brushwork. Gerrit Dou (1613–75) and Jan Steen (1626–79) specialized in dramatically lit genre scenes.

Rembrandt, *The Night Watch*, 1642

Genre

While the word 'genre' can mean a 'type' of art, such as portrait, landscape or still life, 'genre painting' specifically describes often-intimate scenes of everyday life, featuring ordinary people working or relaxing, in mundane environments such as domestic interiors, social gatherings or inn and street scenes. It is generally realistic and unsentimental.

Early examples appear in ancient art, but the term was first used in 18th-century France to describe domestic scenes painted by 17th-century Dutch artists such as Jan Steen and Dirck Hals (1591–1656). Dirck, Frans Hals's younger brother, painted 'merry company' scenes, often also called 'conversation pieces'. In France, the peasant scenes of Le Nain brothers are sometimes classed as genre paintings, as are some works by Jean-Baptiste-Siméon Chardin (1699–1779), particularly his kitchen maids, children and domestic activities. In England, William Hogarth's comical, moralizing narrative scenes of ordinary people were particularly popular among the bourgeois.

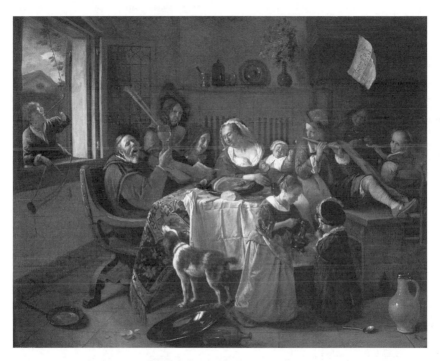

Steen, *The Merry Family*, 1668

Dutch landscape

Following independence from Spain, a sense of national pride pervaded the Netherlands, and several artists began painting the countryside as a subject, rather than a backdrop. Based on sketches made outdoors, Dutch landscape paintings usually had low horizons, emphasizing cloud formations and light effects. Subjects included rivers, meadows, distant towns, the sea, paths and winter scenes. Hendrick Avercamp (1585–1634), an early exponent, specialized in painting crowds skating on frozen lakes. From the late 1620s, artists such as Jan van Goyen (1596–1656) and Salomon van Ruysdael (1602–70) rendered atmospheric effects, and from the 1650s, more expressive compositions with stronger tonal contrasts became prominent. Lone trees, windmills and other buildings were often used to create a focus. The leading artist in this style was Jacob van Ruisdael (1628–82), whose landscapes were accentuated by large, expressive skies. One of his pupils, Meindert Hobbema (1638–1709), excelled at capturing detailed trees and woodland scenes, while Aelbert Cuyp (1620–91) painted peaceful landscapes bathed in light.

Van Ruysdael, *View of Alkmaar from the Sea*, c.1650

Rembrandt

Ranking among the greatest artists of all time, painter, draughtsman and etcher Rembrandt Harmenszoon van Rijn (1606–69) transformed his subjects with technical mastery. His dramatically lit scenes display action, drama or disarming simplicity, and despite personal tragedies, his work never suffered.

At the age of 25, Rembrandt moved to Amsterdam from Leiden, where his dramatic chiaroscuro and atmospheric effects drew attention, and he was soon the city's leading portrait painter. After both his wife and mother died, he painted more mysterious, religious works. Nevertheless, his teaching skills were renowned and pupils flocked to join his studio. One of the first artists to paint directional brushstrokes, following the directions of objects being painted, his later works were captured in even broader marks, often applied with a palette knife. In the 1650s, a huge economic depression forced Rembrandt into a form of bankruptcy. He spent his final 20 years painting commissioned portraits and self-portraits that document the ageing process.

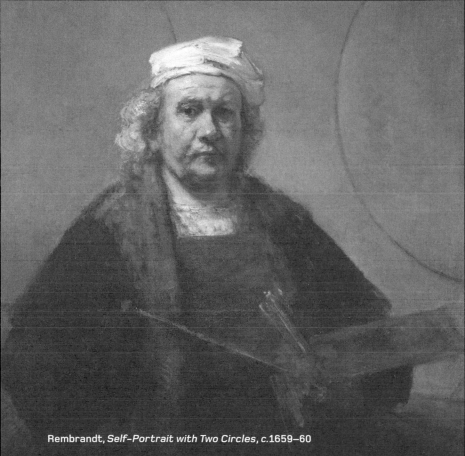
Rembrandt, *Self-Portrait with Two Circles*, c.1659–60

Self-portraits

Before the Renaissance, self-portraits were rare. But after Giotto helped artists take a more prominent role in society, they became a way for some to assert their new status. Highly aware of their public image, van Eyck and Dürer made themselves the subject of several self-portraits. From the age of 13 to 28, Dürer produced at least 12 images of himself, including one closely resembling an icon of Christ (see page 113).

As the centuries passed, artists produced self-portraits for different reasons, often because the sitter comes free, or as self-analysis – as Max Beckmann said: 'One of my problems is to find the self.' Murillo, Velázquez and Goya painted perceptive self-portraits, while Rembrandt and Vincent van Gogh are among the most prolific self-portraitists ever. Rembrandt produced over 40, a visual autobiography of his adult life. Van Gogh's self-portraits served as a form of self-therapy. Between 1886 and 1889, he painted himself 37 times, all with a penetrating look that express his inner anguish.

Van Gogh, *Self-Portrait with Bandaged Ear*, 1889

Delft School

Best known for genre paintings produced between 1650 and 1670, the Delft School was begun by two pupils of Rembrandt, painters Carel Fabritius (1622–54) and Nicolaes Maes (1634–93).

Most Delft School artists were born outside the town, but worked there for varying lengths of time, experimenting with techniques to create convincing pictorial illusions. Before 1650, genre paintings of taverns, gambling and peasants were popular in northern Europe, but the Delft School began depicting respectable, contemporary upper-middle-class households, with refined and elegantly dressed young men and women undertaking genteel activities such as letter writing and music making. This was also one of the first periods in Western art where secular love was depicted directly in paintings. Fabritius experimented with light and perspective, painting dark subjects against light-coloured, textured backgrounds. Maes painted atmospheric images, with glowing colour harmonies, and Pieter de Hooch (1629–84) created quiet, back-lit domestic scenes with few figures.

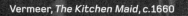
Vermeer, *The Kitchen Maid*, c.1660

Vanitas

From the Latin word for vanity, a vanitas describes a type of still life painting symbolizing the brevity of life and transience of worldly pleasures. Reminding viewers of their mortality and the worthlessness of worldly amusements, vanitas paintings were first seen in the medieval period, but became particularly popular in Flanders and the Netherlands in the 16th and 17th centuries. Ordinary objects were depicted, so viewers understood the connections immediately. They included symbols of art and science, such as books, maps and musical instruments; wealth and power, such as purses, jewellery and gold; earthly pleasures, such as goblets, pipes and playing cards; and death or transience, such as skulls, clocks and burning candles. Occasionally artists included symbols of resurrection and eternal life, such as ears of corn or sprigs of ivy or laurel. Harmen Steenwyck (1612–56) from Delft, is credited with the invention of the vanitas at this time. His paintings, in minutely realistic detail, show varied textures and light. Other vanitas painters included Jan Davidsz de Heem, (1606–84) and Willem Claesz Heda (c.1594–1680).

Steenwyck, *Vanitas*, c.1640

Vermeer

Only about 35 paintings by Johannes Vermeer (1632–75) are known to exist, but he is acknowledged as one of the greatest artists of the Dutch Golden Age. As he spent his whole life in Delft, he is often classed as the leader of the Delft School, but his earliest works of the 1650s include religious, historical and mythological subjects as well as genre scenes. Little is known of his life, but in 1653 he was admitted to the Guild of St Luke, indicating that he had trained for six years. Inspired by Dutch followers of Caravaggio, he experimented with chiaroscuro.

During the 1660s, Vermeer's style grew sharper and more precise, with a luminosity of light and compositions that draw viewers' eyes into the pictures with their clearly defined architectural spaces. For a while he was successful; his small, richly detailed domestic interior scenes with their pearly light attracted local buyers, but he was never wealthy and by 1672 he was in financial difficulty. He died insolvent in 1675, aged just 43, leaving his wife and 11 children in debt.

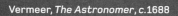
Vermeer, *The Astronomer*, c.1688

Rococo

In reaction to the grandeur, chiaroscuro and drama of the Baroque, 18th-century art became more light-hearted and graceful, with soft colours, natural elements such as acanthus leaves, and elaborate curves and scrolls. Starting in France, and inspired by the indulgent court life of Louis XV, the movement lasted from c.1720–70 and applied to design, painting, literature, architecture, music and sculpture. It was later named the Rococo.

Jean-Antoine Watteau (1684–1721) painted elegantly dressed people relaxing in lush country surroundings. These frolicsome and idealized scenes became called *fêtes galantes* (courtly parties). Other Rococo subjects included mythological stories and portraits, painted with delicate brushwork and sensuous colouring. Rococo sculpture was notable for its intimate scale, naturalism and varied surface effects. Leading Rococo painters included Watteau, Giovanni Battista Tiepolo (1696–1770), François Boucher (1703–70), Jean-Honoré Fragonard (1732–1806), Chardin and Jean-Baptiste Greuze (1725–1805).

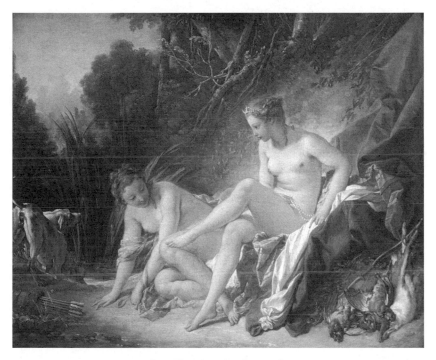

Boucher, *Diana Leaving her Bath*, 1742

The Grand Tour: Venetian light

From the late 16th century, young European aristocrats began concluding their education with extended visits to Paris, Venice, Florence and Rome. At its most popular from c.1660–1820, the trip became known as the Grand Tour. With its exceptional quality of light, the city of Venice became particularly fashionable, and by the 1780s, as many as 40,000 tourists travelled there each year to admire the architecture and the art of Bellini, Giorgione, Titian, Veronese and Tiepolo (often considered the greatest Italian Rococo painter whose animated works incorporate many figures and unusual viewpoints, in luminous colours and rich textures). Many tourists took home souvenirs – often large scenic paintings or *vedute* such as those by Canaletto (1697–1768) and Francesco Guardi (1712–93). Canaletto's paintings are characterized by clarity of light, precise perspective, sharp tonal details and glass-like finishes. His fine brushwork created sparkling impressions of the water, skies, architecture and human activity, while Guardi's free handling of paint captured the atmosphere and dazzling effects of light on water.

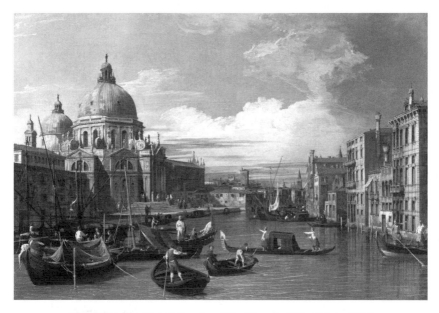

Canaletto, *The Grand Canal and the Church of the Salute*, 1730

The Age of Enlightenment

From the 1650s to the 1780s, a shift in thinking occurred that became known as the Enlightenment. This period of intellectual, social and political ferment began in France, but spread rapidly across Europe and beyond. Focusing on intellectual thought and reason, it supported the advance of science and human rights, while challenging religious intolerance and corruption in Church and State. Expanded education helped the middle classes gain more autonomy. For the first time, a broader audience became interested in science, while new political ideas resulted in notions of democracy that eventually supplanted autocratic royal constitutions. Enlightenment thinkers developed new theories on education, economics, law, the workings of the universe and social and political reform.

Amid all this speculation, the taste for superficial aesthetics diminished. As many Enlightenment thinkers believed they were living in a new Renaissance, the arts of antiquity were once again considered the height of discernment.

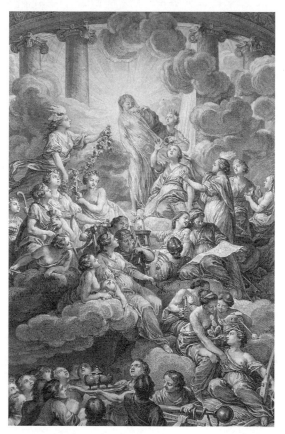

Cochin,
Frontispiece to
L'Encylopédie, 1772

18th-century British painting

While the Rococo was flourishing in France, different approaches to art emerged elsewhere. In Britain, inspired by new types of literature, or novels, that were often cautionary tales of vanity, dishonesty and duplicity, William Hogarth (1697–1764) created satirical paintings and prints. His visual stories were widely copied, and he lobbied in Parliament for greater legal control over the reproduction of artists' work. The result was the 1735 Engravers' Copyright Act (known as 'Hogarth's Act').

Joseph Wright of Derby (1734–97) trained as a portrait painter, but became renowned for his dramatically lit scenes. His use of strong chiaroscuro show the influence of Caravaggio and Rembrandt. Following a close study of equine anatomy, George Stubbs (1724–1805) painted horses and scenes of peasant life. Thomas Gainsborough (1727–88) painted portraits and landscapes with a light palette and free brushstrokes, while Sir Joshua Reynolds (1723–92) painted dignified portraits using rich colours, strong lighting and a loose application of paint.

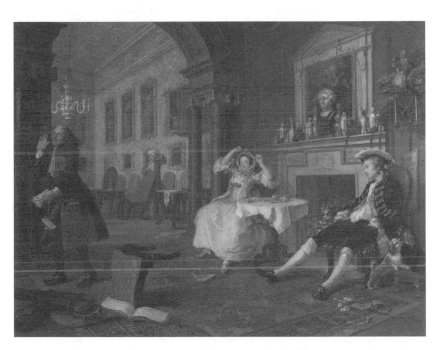

Hogarth, *Marriage á–la–Mode*, c.1743

Animals

Some of the earliest known art depicts animals, either carved or painted on cave walls, and animals continue to be featured in art in many different cultures, as symbols, mythical creatures, gods or as themselves. Renaissance portraits of ladies or children often include animals such as a pet squirrel or dog, and by the 18th century, portraits of a favourite horse or dog, prize livestock or wildlife were commissioned by the wealthy.

In Britain, George Stubbs specialized in lifelike paintings of horses and later Edwin Henry Landseer (1802–73), the favourite artist of Queen Victoria, became best known for his lion sculptures in London's Trafalgar Square. Edgar Degas was once as famous for his energetic horse paintings and later sculptures as for his dancers, while monkeys appeared symbolically in paintings by Georges Seurat and Frida Kahlo. Franz Marc, a German Expressionist, perceived animals to be on a higher plane than humans, and painted many in bright, unnatural colours and fragmented compositions.

Landseer,
Monarch of the Glen,
1851

Neoclassicism

Partly in reaction to the frivolity of the Rococo, and partly developing from the ideas of the Enlightenment, Neoclassicism was particularly inspired by the discovery in the mid-18th century of Pompeii and Herculaneum – two ancient Roman cities buried beneath the volcanic ash of the eruption of Mount Vesuvius in 79 CE. Such preservation of art and architecture reignited a belief in ancient Greek and Roman virtues such as courage and patriotism, and motivated contemporary artists and architects to follow similarly clean lines and contours.

Neoclassicism was also closely linked with changing politics in France. Ennobling and inspiring themes of sacrifice and heroism prevailed. The movement's most influential figures were David, Ingres and Anton Raphael Mengs (1728–79). Among sculptors, Jean-Antoine Houdon (1741–1828) is renowned for his portrait busts and statues of Enlightenment philosophers, inventors and political figures, while Antonio Canova (1757–1822) from Venice, is famous for refined marble sculptures that delicately render flesh.

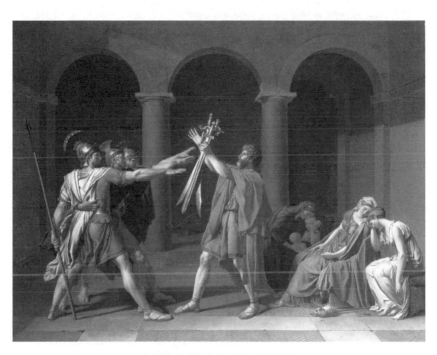

David, *Oath of the Horatii*, 1786

David and Ingres

The pre-eminent Neoclassical painter, Jacques-Louis David (1748–1825) had an academic style of history painting that suited the mood of the time. In 1774, he won the Prix de Rome, enabling him to study for five years at the French Academy in Rome. Here, he discovered a fascination for classical art and antiquities. Back in Paris, he became as passionate about politics as art, narrowly avoiding the guillotine twice for revolutionary activities. Appreciating his patriotism, clarity and purity of style, in 1802 Napoleon made him a knight of his new Legion of Honour.

After training briefly with David, Jean-Auguste-Dominique Ingres (1780–1867) also won the Prix de Rome. He spent 17 years in Italy, studying Renaissance art and making a living selling pencil portraits. He also began painting bathers, a theme that he revisited throughout his career. His elongated, smooth-skinned nudes epitomized his belief in accuracy of line. By the late 19th century, he was celebrated as David's equal for his skilful paintings with cool colours, smooth contours and imperceptible brushmarks.

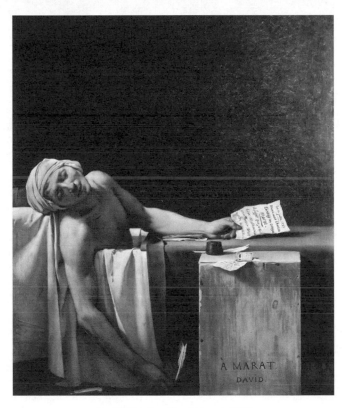

David, *The Death of Marat*, 1793

Sculpture

The earliest sculpture seems to have begun with artists modifying found objects to represent animal or human forms. As tools and technologies improved, artists progressed from carving bone, wood and stone to manipulating clay and firing in bronze. Today, a wide variety of materials are carved, welded, modelled, moulded and cast. In many cultures, sculpture has been central to religious ceremonies or political propaganda, and aside from pottery, stone sculpture represents most surviving three-dimensional art from ancient times – most wooden pieces are lost.

Sculpture of bronze and other alloys developed independently in various cultures, including South America, China, ancient Egypt and West Africa. Techniques include lost-wax casting, plaster-mould casting and sand casting. Wood carving flourished particularly in medieval Europe, and stone carving reached astonishing heights in ancient Greece and later during the Renaissance. Classical statues were usually painted to enhance their realism. From 1917, found objects were once again presented as finished works of art.

Michelangelo, *David*, 1501–4

History painting

From the High Renaissance until the 19th century, history painting was considered the most important and prestigious artistic genre in Western art. In this context, the word 'history' relates to the Italian word *istoria*, meaning a narrative or story – so history paintings can represent historical events, biblical or mythological stories, allegories or other forms of secular literature. Traditionally, history paintings had to incorporate several figures in some sort of emotionally charged activity. In his 1435 treatise *On Painting*, Italian art expert Alberti described istoria as the most difficult type of painting, and emphasized the importance of portraying interaction with gesture and expression.

History painting was originally created to decorate public areas, such as in churches, town halls and palaces. Usually painted on a grand scale, history paintings conventionally created serious, morally uplifting narratives to inspire and educate contemporary viewers. In the late 19th century, as artists began to rebel against the art establishment, history painting became less significant.

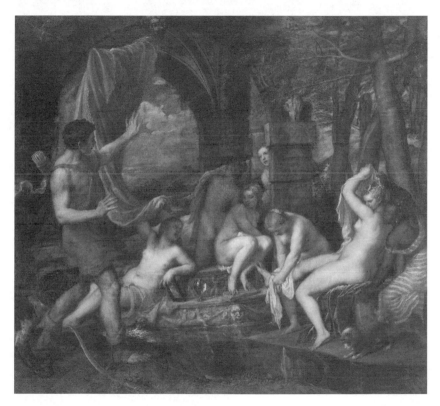

Titian, *Diana and Actaeon*, 1556–9

Japanese prints

During Japan's Edo period (1615–1868), the country was economically stable but closed to foreign trade. In the 1660s, Japanese artists had begun painting *Ukiyo-e*, or 'pictures of the floating world', depicting the pleasure districts of Edo (modern Tokyo). In *c.*1675, Hishikawa Moronobu (1618–94) produced the first *Ukiyo-e* woodblock prints and later, Suzuki Harunobu (1725–70) made full-colour 'brocade prints'. Katsushika Hokusai (1760–1849) created *Thirty-Six Views of Mount Fuji*, which includes the famous *Great Wave off Kanagawa*, and Andō Hiroshige (1797–1858), also known for landscapes, produced *The Fifty-Three Stations of the Tōkaidō* and *The Sixty-Nine Stations of the Kiso Kaidō*.

After 1853, Japan resumed trade with the West, and the prints, with their asymmetrical compositions, flat colours and absence of perspective, inspired countless Western artists and designers. The resulting wave of Japonisme (see page 244) articulated by individuals including James McNeill Whistler and Henri de Toulouse-Lautrec, influenced several later art and design styles.

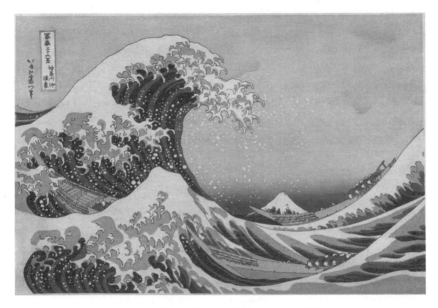

Hokusai, *Great Wave off Kanagawa*, c.1832

Watercolour

The term 'watercolour' refers to both a type of paint and the artwork made with it. The paint is made of pigments mixed with gum arabic and thinned with water. Usually fluid and translucent, some pigments are more opaque than others. Variations of watercolour have been used for centuries, from ancient Egypt to the Byzantine and Romanesque eras. It was also used extensively for medieval manuscript illumination, while some of the earliest Chinese artists painted on silk with water-based inks and dyes. Dürer used watercolour in several works, and by the 18th century, many young men recorded their Grand Tours in watercolour.

Initially, artists ground their own watercolours from natural pigments, but in 1784, William Reeves invented small, hard cakes of soluble watercolour, and from the 1830s, portable, moist watercolours in porcelain pans were available. From the late 18th to the mid-19th century, the market for domestic art contributed to the growing popularity of watercolours. In Britain, this period was later known as the Golden Age of Watercolour.

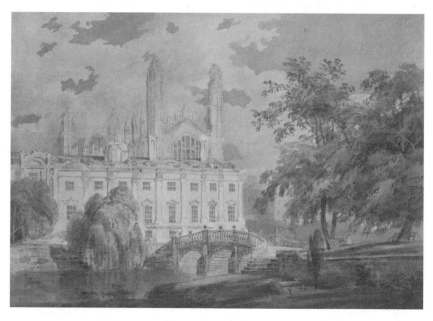

Turner, *Clare Hall*, 1793

Chinese Qing Dynasty

The last imperial dynasty of China, the Qing, ruled from 1644 to 1912, and created the largest and wealthiest empire in the world. Expanding into Central Asia, Tibet and Siberia, their economic success resulted in increased patronage of the arts, which mixed the Qing's own Manchu traditions and language with older Chinese styles and customs. Qing emperors were generally conservative in their tastes, and early Qing art was dominated by two styles of painting: the Six Masters of the Early Qing, who followed the conventions of Chinese landscape painting, copying past masterpieces with fine, even and distinct marks, and the Four Great Monk Painters, who used landscapes to express contemporary feelings and political views, painting spontaneously with delicate and expressive brushstrokes.

Increased wealth among the merchant class stimulated demand for crafts such as textiles and pottery, often decorated with meticulously painted scenes in bright colours. In the 18th century, exotic statues and artefacts filled newly built Buddhist temples.

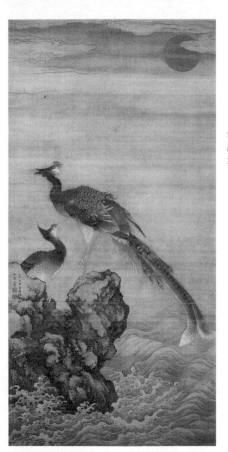

Shen Nanpi,
Pair of Phoenixes,
1735

Islamic art

During the 17th and 18th centuries, Islamic art blossomed across three Islamic Empires: the Ottoman Empire from Turkey to Tunisia, the Safavids in Iran, and the Mughals in India. The Ottomans produced magnificent architecture such as the Blue Mosque in Istanbul, decorated tiles and pottery, and exacting manuscript and book illustrations. Safavid art, meanwhile, featured Chinese and Mongol influences.

Mughal art at first displayed features of Ṣafavid art, but later followed its own path. It developed under the emperor Humāyūn (1530–40 and 1555–56), through two Persian artists, Mīr Sayyid ʿAlī and Khwāja ʿAbd al-Ṣamad. Humāyūn's son Akbar (1556–1605) employed more court painters and commissioned dynamic illustrated histories with elements of realism and naturalism. Under Jahangir (1605–27), it developed further. Inspired by European painting, brushwork became finer and colours lighter. In the reign of Shah Jahan (1628–58), it was architecture that reached new heights, culminating with the Taj Mahal in 1648.

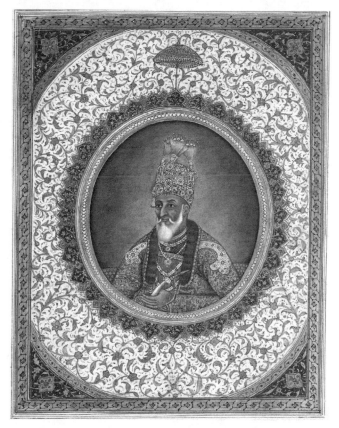

Shen Nanpi,
Bahadur Shah II,
1844

Hindu art

Rajput or Rajasthani painting emerged from Hindu India at the end of the 16th century. Characterized by bold drawing and vibrant colours, most paintings were miniatures, although some were larger, decorating walls of palaces and other important buildings. Rajasthani artists idealized feminine beauty and expressed love scenes, stories from Krishna's life and landscapes in precise detail. The style evolved and flourished in the royal courts of Rajputana, and each Rajput kingdom developed a distinct style, albeit with certain common features, combining Persian, Mughal, Chinese and European influences.

The Pahari School developed in the foothills of Punjab, Garhwal and Jammu, and became known for flat images painted with flowing lines and brilliant colours. Influenced by Mughal art, Pahari paintings were mostly miniatures, and developed and flourished from the 17th to the 19th century. After Delhi was sacked in 1739, many Mughal artists went to Rajput courts and synthesized their styles with Pahari paintings.

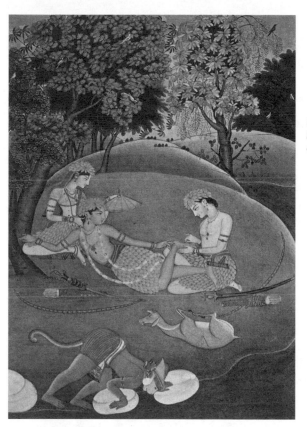

Unknown artist,
Rama and Sita,
c.1780

Romanticism

A longside Neoclassicism, an artistic, literary and intellectual movement developed that focused on the emotions. Emerging partly as a reaction against the cool reason and moral purpose of Neoclassicism, and partly in accord with it, Romanticism was interpreted differently by artists, writers and composers, developing as a diverse movement across Europe from the late 18th to the late 19th century. Like Neoclassicism, it reflected elements of the revolutionary spirit, but contrastingly, it displayed passions with painterly brushwork and vivid colours, or imaginatively composed statues.

Romantic artists favoured colour over line and moved away from idealized representations of the classical past in favour of imagination, intuition, and more individual and varied ideas. Eugène Delacroix and Théodore Géricault pioneered the movement in France, while Francisco de Goya produced powerful evocations of events in Spain, and Britain's William Blake (1757–1827) created visionary and symbolic images and poems.

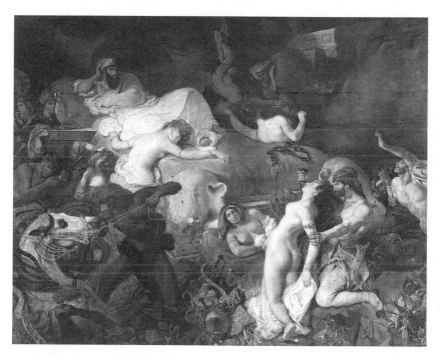

Delacroix, *The Death of Sardanapalus*, 1827

Goya

Through art that encapsulated the turbulence of late 18th and early 19th century Spain, Francisco de Goya (1746–1828) became known as the last Old Master and the first great modern artist. During his life, dramatic upheavals occurred across Europe, often triggered by power-hungry autocratic monarchs. Goya lived for 82 years and worked as an artist for more than 60 of them. As a commentator and chronicler of his era, he influenced generations of younger artists. His enigmatic images vividly capture Spain's changing fortunes in the 18th and 19th centuries, satirizing contemporary attitudes and events.

Appointed painter to Charles III and principal court painter to Charles IV of Spain, Goya also painted for the self-appointed King Joseph, Napoleon's brother, after the French invasion of Spain. Yet in 1792, a serious illness left him permanently deaf and he became introspective. His work expressed his insightful, sardonic thoughts about the problems of Spain and Europe, yet despite living in dangerous times, he was never called to account.

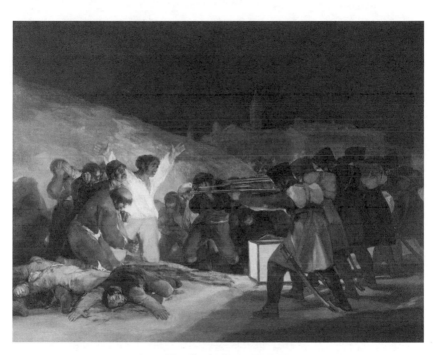

Goya, *The Third of May 1808*, 1814

Géricault

Exemplifying the Romantic movement, Théodore Géricault (1791–1824) was inspired by Delacroix and influenced many other artists in turn. By exploring emotionally heightened themes with marked realism, he expressed human experiences such as suffering, death and triumph. A painter and lithographer, his disregard for convention helped to elevate him to legendary status during a tragically short career of just 12 years.

After studying with Neoclassical painter Pierre-Narcisse Guérin (1774–1833) and copying works in the Louvre, Géricault initially painted with a strong influence of Rubens. After two years in Italy, he also began integrating elements of Caravaggio's chiaroscuro and Michelangelo's drama. Soon, his personal energy and emotional intensity took over, as he disregarded traditional history painting styles and broke with convention. His impassioned, larger than life-sized 1819 painting, *The Raft of the Medusa*, with its morbid depiction of human suffering, drama and strongly contrasting effects of light, proved highly controversial.

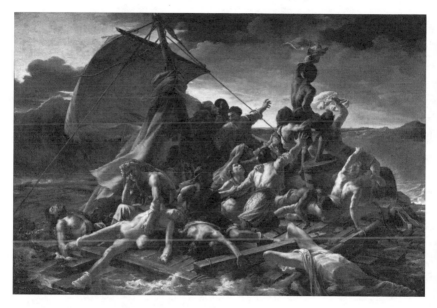

Géricault, *The Raft of the Medusa*, 1819

Delacroix

The leading Romantic painter in France, Eugène Delacroix (1798–1863) was admired by his contemporaries and also influenced the development of Impressionism, Post-Impressionism and Symbolism. Like Géricault, he was trained by Guérin, but he developed a personal, emotional style and palette through studying Rubens and 16th-century Venetian painters in the Louvre. Opposing the exactitude of Neoclassicism, he advocated spontaneity in painting, maintaining that colour and passion were more important than meticulous drawing.

In 1824, he won a gold medal at the prestigious Paris Salon. The following year he stayed in England, while later visits to Spain, Morocco and Algeria inspired richer colours, and more dynamic brushwork and compositions. His subjects included historical and contemporary events and literature, and his output in painting, printmaking and writing was vast. Through intense rivalry, Ingres delayed his election to the Institut of France, but in 1857 he was admitted, and also began teaching at the École des Beaux-Arts.

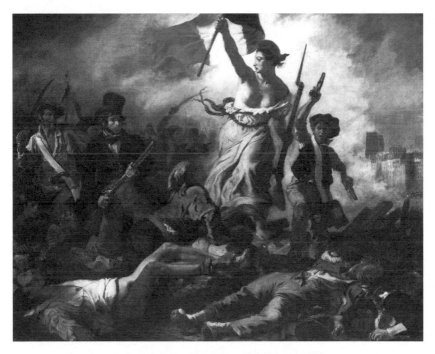

Delacroix, *Liberty Leading the People*, 1830

Landscape

Paintings of the natural world have appeared in various cultures at different times, usually as backgrounds. However, Chinese *shan shui* ('mountain-water' or 'pure') landscape painting developed during the Liu Song Dynasty (420–479 CE). Before the 18th century, most Japanese artists followed the Chinese idea that idealized landscapes were the most appropriate subject for secular painting. Frescoes of imaginary panoramas were also painted in the ancient Roman cities of Pompeii and Herculaneum.

The 17th-century Dutch Golden Age inspired interest in landscape as a subject in itself, and by the 18th century, artists such as Canaletto, Guardi and Claude flourished. In England, an entire landscape movement developed, with painters including John Constable (1776–1837), J.M.W. Turner and Thomas Girtin (1775–1802) bringing new energy into the genre. Constable and Turner's innovative practice of painting in oils in the open air was taken up across Europe. Meanwhile in Germany, Caspar David Friedrich (1774–1840) created mysteriously illuminated, ethereal landscapes.

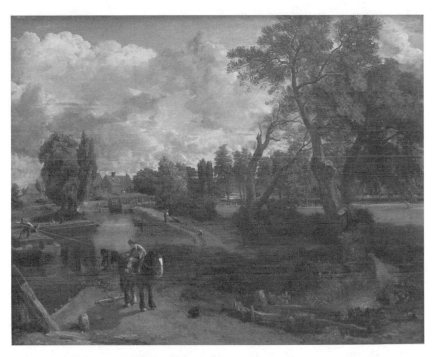

Constable, *Flatford Mill*, 1816–7

Composition

The arrangement of elements in a work of art is imperative. 'Good' composition attracts and holds interest, while 'bad' composition repels. Focal points, or centres of interest, draw viewers into images, and also important are shape, proportion, balance, harmony, negative and positive space, horizontal, vertical or diagonal lines, and tone, rhythm and viewpoint. Certain compositional arrangements are used repeatedly by painters, such as triangular or pyramidal, which create a sense of harmony, or x-shaped, as seen in Van Gogh's *Café Terrace at Night* and Cézanne's *The Card Players*. Another effective arrangement is 'the rule of thirds', developed from the golden mean or golden ratio. Used extensively during the Renaissance, this uses mathematical proportions to create balanced compositions. Using only vertical and horizontal elements and primary colours, Piet Mondrian created stable compositions representing positive and negative, masculine and feminine. While asymmetry can create a sense of stability and balance, asymmetry, as in many *Ukiyo-e* compositions, can be more interesting and dynamic.

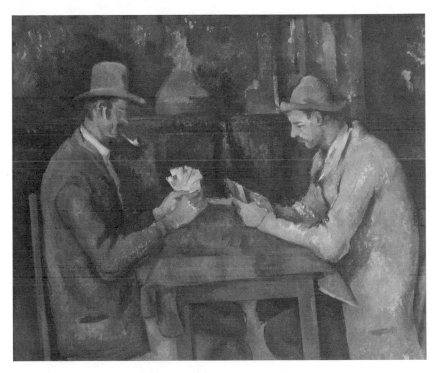

Cézanne, *The Card Players*, 1894–5

Turner

The most famous landscape painter of the Romantic movement, the precociously talented J.M.W. Turner (1775–1851) became one of the youngest full members of Britain's Royal Academy of Arts at 27. His early landscapes were influenced by Claude and Dutch painters such as Ruisdael, as well as Joseph Wright of Derby and Poussin, while his later, atmospheric works had a profound effect on many subsequent artists and movements, including Impressionism and Abstract Expressionism. Hugely productive, Turner painted almost incessantly, around Britain and abroad. As his career flourished, he became more innovative, using freer brushwork, sweeping strokes and colours that evoke the light and mood of each scene. With a brilliant palette and original methods, including dissolving shadows and edges, blurring distinctions and unusual compositions, his work was revolutionary for the time. In later life, to ensure his paintings' freshness, he sent unfinished canvases to exhibitions, finishing the painting in the gallery on 'Varnishing Days' before the opening. He became renowned as the 'painter of light'.

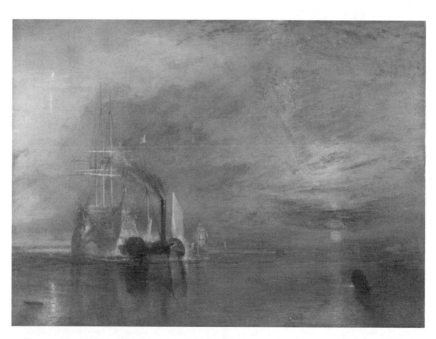

Turner, *The Fighting Temeraire Tugged to her Last Berth to be Broken Up,* 1838

Drawing

Paul Klee (1879–1940) once wrote: 'a drawing is simply a line going for a walk'. Using materials such as pencil, charcoal, ink or coloured pencil, drawing is one of the major forms of expression within the visual arts, with artists using methods including line, stippling, hatching and cross-hatching. After pencils were first manufactured early in the 19th century, they became the preferred drawing tools of many.

The earliest known drawings are found on cave walls dating from 30,000 BCE. Ancient Egyptian craftsmen and medieval artists made careful preparatory sketches and outlines for finished works. In the late 14th century, drawing became more important for itself, largely through the rise of naturalism instigated by artists such as Giotto and the Northern Renaissance artists' detailed approach. Leonardo filled his notebooks with detailed, lifelike drawings and diagrams, while Dürer demonstrated his proficiency in detailed, intricate drawings, ultimately leading to drawing becoming considered the foundation for all the arts.

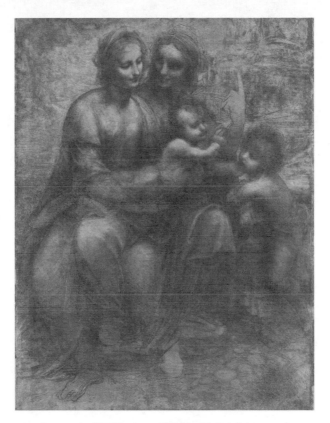

Leonardo, *The Virgin and Child with Saint Anne and Saint John the Baptist*, c.1500

Academic art

From the 17th to the 19th century, the art academies of Europe wielded great power in the art world. Students aspired to join them, exhibit with them and win competitions, but to do this, they had to conform to strict demands.

The Académie des Beaux-Arts in Paris was the most important, awarding the Prix de Rome, a fellowship to study at the Académie Française in Rome. Entrants had to be French, male, under 30 and single. Exhibitions included the annual Paris Salon where exhibits were selected by a strict panel who favoured a certain style. Synthesizing the careful contours of Neoclassicism and (if painting) the intense colours of Romanticism, Academic art (also called Academism or L'Art Pompier) had a highly refined style and moralistic tone. Brushstrokes or carved marks had to be imperceptible, the hierarchy of subjects had to be adhered to. Among the greatest exponents were Jean-Léon Gérôme (1824–1904), William-Adolphe Bouguereau (1825–1905), Thomas Couture (1815–79) and Hans Makart (1840–84).

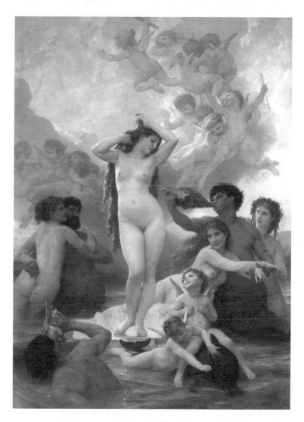

Bouguereau, *The Birth of Venus*, 1879

The Pre-Raphaelite Brotherhood

In 1848, a group of seven young English painters, poets and critics formed the Pre-Raphaelite Brotherhood, intending to return to painting in the uncomplicated styles practised in Italy before Raphael and Michelangelo. Rebelling against the artifice of Academic art, they painted realistically, using small brushstrokes and jewel-bright colours on wet, white grounds. They explored religion, literature, poetry and modern social problems, and they signed their paintings anonymously 'PRB'. The main members were William Holman Hunt (1827–1910), John Everett Millais (1829–96) and Dante Gabriel Rossetti (1828–82). Initially, PRB paintings were criticized for their disregard of academic ideals and apparently irreverent depictions of holy figures. But the leading art critic, John Ruskin (1819–1900), defended them and they became extremely successful. The group had dispersed by 1854, but a second phase occurred in the 1860s, led by Rossetti, Edward Burne-Jones (1833–98) and William Morris. Continuing to pursue PRB aims, the new group explored romantic symbolism and medieval legend.

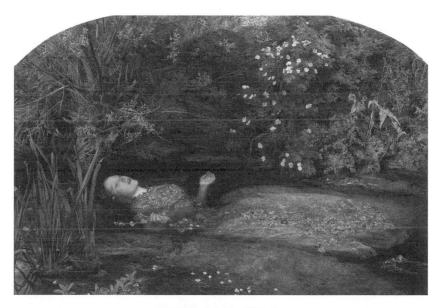

Millais, *Ophelia*, 1851–2

Arts and Crafts

Instigated by the writings of John Ruskin and the beliefs of designer, writer and activist William Morris (1834–96), the Arts and Crafts movement began in Britain in the 1860s, before sweeping across Europe and North America. Aiming to reform art and design to improve society, it particularly opposed the cheapness and poor design of mass-produced goods that were the result of the Industrial Revolution, supporting products that were made by designers who took pride in their work, using quality materials and simple designs based on nature.

In 1861, Morris co-founded a firm of interior decorators and manufacturers. Known after 1875 as Morris & Co, it was dedicated to recapturing the careful workmanship of medieval crafts, hand-producing metalwork, jewellery, wallpaper, textiles, ceramics, furniture and stained glass. In 1890, he also established the Kelmscott Press to publish quality editions of contemporary and historical English literature. Ultimately however, most people could not afford such costly, hand-made goods.

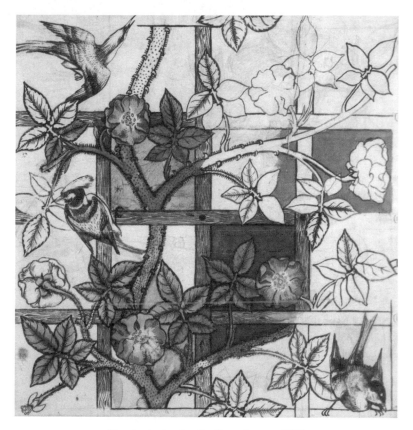

Morris, design for *Trellis* wallpaper, 1862

Photography

The invention of photography in 1839 had a huge impact on art, changing artists' ideas and approaches forever. At first, many thought it would make painting redundant. Then, some artists began using the technology to help them. In the 1870s, US-based English photographer, Eadweard Muybridge (1830–1904) used several cameras and relatively fast shutter speeds, to study horses and humans in motion. Capturing the details of such movements helped artists to represent them accurately.

After a difficult start, painters began to use photography as a tool, often in preparation for paintings. Some photographers, such as Julia Margaret Cameron (1815–79) and Alfred Stieglitz (1864–1946) helped to turn the medium itself into an art form. Photography also gave artists fresh ideas: Gustave Courbet (1819–77), Gérôme and Degas used it extensively to assist their observation of details and create interesting compositions. For instance, photographs allowed Degas to create unusual viewpoints and 'cut off' elements at the edges.

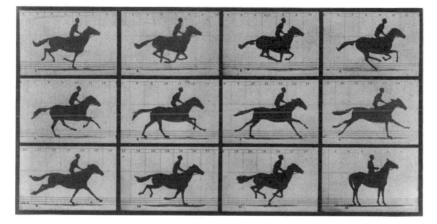

Muybridge, *The Horse in Motion*, 1878

Hudson River School

Influenced by Romanticism, between c.1825 and 1870, a number of American landscape painters worked around the Hudson River near New York. Although most of the artists had studied in Europe at some point, this was the first native school of painting in the USA. Their paintings depict an American landscape in which humans and nature exist harmoniously together. Paintings are realistic, detailed and often idealized.

Early leaders of the movement were Thomas Doughty (1793–1856), Asher B. Durand (1796–1886) and Thomas Cole (1801–48), all of whom painted carefully observed, atmospheric pictures in the open air. Doughty's serene views were of the river valley itself, Durand's lyrical woodland scenes featured delicate lighting, while Cole preferred stormy, monumental aspects of nature. Along with Albert Bierstadt (1830–1902), Frederic Edwin Church (1826–1900) was the school's most successful painter. Emphasizing light, his panoramic landscapes captured both his home, and travels to areas including Niagara Falls, Labrador, Jamaica, Mexico and the Middle East.

Asher Brown, *The Catskills*, 1859

Orientalism

Predominantly executed by French and British artists, Orientalism describes 19th-century realistic-looking (though not necessarily accurate) paintings of the exotic East, including present-day Turkey, Morocco and Egypt. Subjects include landscapes, harems and slave markets. Although the artists who painted them were of different generations, enthusiasm for the theme was inspired partly by Napoleon Bonaparte's 1798 invasion of Egypt. Artists who explored the theme included Jean-Étienne Liotard (1702–89), Antoine-Jean Gros (1771–1835), Gérôme, Ingres, Delacroix, Théodore Chassériau (1819–56), William Holman Hunt, Auguste Renoir (1841–1919) and Matisse.

The taste expanded to a fashion for Eastern architectural motifs, furniture and interior decoration. Proponents of the Aesthetic movement of the 1860s, who believed in beauty for its own sake, were great enthusiasts for Oriental interiors. For instance, Frederic Leighton (1830–1896) decorated his London home with fountains and mosaic tiles collected on journeys to the East.

Gérôme, *On the Desert*, c.1860

Portable paints and chemical colours

Artists have painted outdoors for centuries, but it was not until the mid-19th century that finished paintings were produced outside. Inventions made this easier: originally, artists had made their own paint by grinding and mixing pigments with egg or oil, but from the end of the 18th century, the first ready-made paint was sold in pigs' bladders. Paint was squeezed through a tiny hole in the bladder, which was then sealed with a tack, but it was messy. In 1841, the first collapsible metal tubes of ready-mixed paint were produced. Portable paints enabled artists to paint *en plein air* ('in the open air'), and folding easels and portable paint boxes also became available. Soon manufacturers sold pre-stretched canvases already primed with white gesso.

Additionally, new artificial pigments were created. New colours and improved versions of established ones began appearing. Cobalt blue was first sold in 1807, cadmium yellow in 1820 and viridian in 1838. These were followed by cheap synthetic versions of other colours, such as French ultramarine, zinc white and cobalt violet.

Pissarro, *The Artist's Palette with a Landscape*, c.1878

Barbizon School

After Constable's paintings won a gold medal at the 1824 Paris Salon, his large landscapes and open-air oil sketches inspired a group of young French artists who began painting in the village of Barbizon near the Forest of Fontainebleau. Expressing romantic views of nature, they usually sketched outdoors but completed paintings in their studios. They became known for their loose brushwork, patches of unblended colour and light-reflecting tones; in making landscape an independent subject, they were important precursors to Realism and Impressionism.

Artists of the Barbizon School included Jean-Baptiste-Camille Corot (1796–1875), Jean-François Millet, Theodore Rousseau (1812–67) and others. Rousseau's direct applications of small, highly textured brushstrokes presaged the Impressionists. After travelling in Italy and France, Corot's paintings and oil sketches were clearly defined and fresh, using bright colours in fluid strokes, but from the 1850s, his style became softer, his palette reduced and his landscapes atmospheric.

Corot, *Landscape near Riva on Lake Garda*, 1835

Realism

By the mid-19th century, the Western world was experiencing profound changes, with industrialization and the rapid growth of towns, cities, populations and the middle classes. Particularly in France, a new generation of artists sought to express this modern world. Dutch artists had painted everyday realities in the 17th century, but influenced by photography, the new Realists took an even more direct approach. The academies, meanwhile, maintained that reality was not a suitable subject for art.

Some traces of realism emerged in the 17th and 18th century works of Velázquez and Goya, but the Realists were reacting to what they perceived as the excesses of Romanticism and Neoclassicism, the artificiality of Academic art, and the imperiousness of the academies. They also expressed their sympathies for the daily hardships of ordinary working people. Realists included Millet, Corot, Gustave Courbet, Honoré Daumier and Manet. The movement particularly inspired American painter Thomas Eakins (1844–1916).

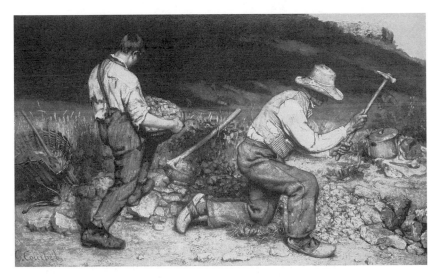

Courbet, *The Stone Breakers*, 1849

Courbet, Millet and Daumier

Gustave Courbet (1819–77) originally used the term Realism to describe his own work, and later issued a manifesto on the subject. Breaking with artistic conventions by painting scenes of ordinary people on the vast canvases that the Académie regarded as only suitable for history painting (effectively making the poor as important as the rich), his radical beliefs and style were initially ridiculed, but later hailed by avant-garde artists as revolutionary and influential. Jean-François Millet (1814–75), a founder of the Barbizon School, also began painting the hardships of peasant life, demonstrating his strong feelings about social injustice. Influenced by Chardin and 17th-century Dutch art, his work in turn influenced others including Jozef Israëls (1824–1911) and Van Gogh.

Close analysis of social problems can also be seen in the paintings, lithographs and sculptures of Honoré Daumier (1808–79), many of which were published in satirical political journals. Although he was best known for his critical caricatures, his expressive, direct and powerful painting style epitomized Realism's aims.

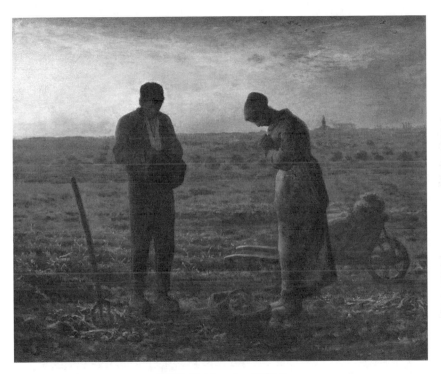

Millet, *The Angelus*, 1857–9

Manet

One of the first 19th-century artists to paint modern life, Édouard Manet (1833–82) was integral in the transition from Realism to Impressionism. With his absence of half tones, flattening of forms, restricted palette, bold brushwork and irreverent subject matter that disregarded the conventions of Academic art, he painted contemporary life and impressions of passing moments. Perceived as shocking at the time, these ideas later became crucial elements in Impressionism and Manet's influence continued in many subsequent movements.

Greatly influenced by Velázquez and other Old Masters, Manet sought acceptance despite repeated rejections from the Paris Salon. In 1863, he exhibited a painting at the Salon des Refusés, an alternative exhibition for art excluded by the Salon. Featuring a naked woman between two clothed men, the work scandalized the public, but inspired several young artists who later became the Impressionists. Although Manet never exhibited with them, they became close friends and they saw him as their unofficial leader.

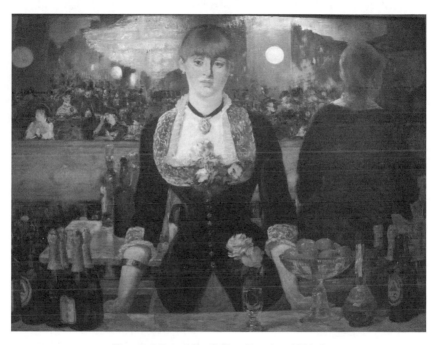

Manet, *A Bar at the Folies–Bergère*, 1881–2

Aesthetic movement

Inspired predominantly by Pre-Raphaelitism, an art movement developed in France and Britain in the 1860s that focused almost entirely on beauty. It began in reaction to what was viewed as the ugliness of the industrial age, and manifested in fine art and design simultaneously. Artists involved (Aesthetes), included James McNeill Whistler (1834–1903), Albert Moore (1841–93), Leighton and Burne-Jones. They used soft colours in complex juxtapositions, subtle blending techniques and emphasized beauty and decoration. The phrase 'art for art's sake', identifying beauty as the most important element in fine art and design, was popularized by French poet and critic Théophile Gautier (1811–72) and later reflected in the writings of Oscar Wilde (1854–1900) and the illustrations of Aubrey Beardsley (1872–98).

With his designs inspired by Japanese prints, harmonious tones and colours, Whistler exemplified the movement, but also shared affinities with the French Symbolists. Burne-Jones's ethereal, graceful paintings, helped inspire later Art Nouveau.

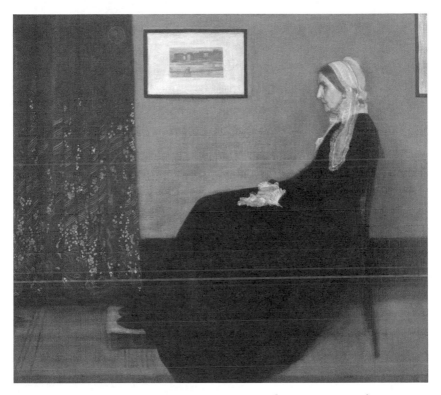

Whistler, *Arrangement in Grey and Black No. 1 (Whistler's Mother)*, 1871

Impressionism

Rejected by the art establishment for their radical approach, in 1874, a group of artists exhibited independently in Paris. They included Monet, Renoir, Camille Pissarro (1830–1903), Edgar Degas (1834–1917), Cézanne, Alfred Sisley (1839–99), Frederic Bazille (1841–70), Mary Cassatt (1844–1926) and Berthe Morisot (1841–95). An art critic derisively nicknamed them 'Impressionists' after Monet's painting *Impression, Sunrise*, and the name stuck. Capturing transitory moments, the Impressionists applied sketchy, rapid brushmarks and bright colours, often using newly-available synthetic pigments, emphasizing changing weather and qualities of light. They often painted *en plein air*, and many adopted Manet's *alla prima* ('at once') technique. Most painted from unusual viewpoints and used colours in shadows. Contrasting with Académie preferences, they painted contemporary life, avoiding symbolism or underlying meanings. They extended ideas from Realism, the Barbizon School, Japanese prints, industry, scientific colour theories and Delacroix. Photography was also influential – both for its technique of working with light and as a practical aid.

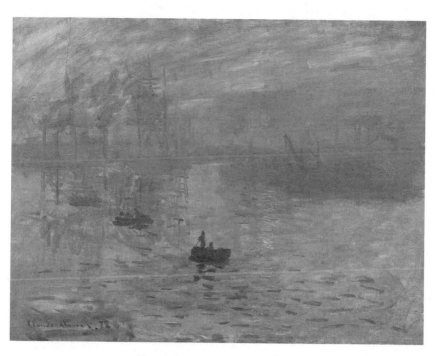

Monet, *Impression, Sunrise*, 1872

Light

From Caravaggio's tenebrism to Claude's golden glow, and from Friedrich's soft diffusions to Monet's vibrant colours, painters have always depicted light to enhance their effects. Depending on how it is used, light can create tonal contrasts, mood, atmosphere or something more tangible. Caravaggio, Wright of Derby, Gentileschi and de la Tour often used a single light source to focus viewers' attention on important elements in their paintings: strong light effects create drama and an impression of depth.

In a skilful artist's hands, light can be soft and gentle or sharp and bright, it can be uplifting or claustrophobic, mysterious or clear, warm or cool. Backlit landscapes draw viewers' eyes to the horizon, while light shining from the front casts a spotlight on the main action. Turner used bright colours and white, influencing the Impressionists who concentrated on capturing the optical impressions of light and its changing characteristics and moods in small, vibrantly coloured paint marks, often painting *alla prima* – or in one go – to capture shifting light effects.

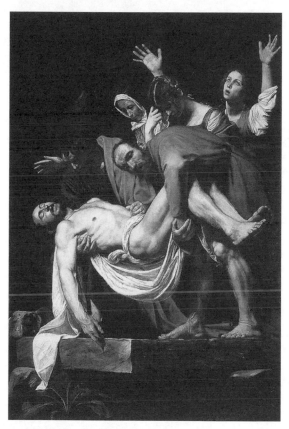

Caravaggio,
The Entombment of Christ,
c.1602–3

Japonisme

Whistler, Degas, Cassatt, Manet, Van Gogh and many other artists were fascinated by Japanese design, and many collected *Ukiyo-e* prints. After 200 years of isolation from the West, Japan began trading with the rest of the world in 1853. This led to a plethora of goods, including prints, textiles and artefacts arriving for sale in Europe from Japan. Japanese goods were also displayed at exhibitions such as the 1862 International Exhibition in London, and the 1867 Exposition Universelle in Paris. A craze for all things Japanese swept through France and Britain in particular, influencing paintings, fashions and decoration. In 1872, art critic Philippe Burty (1830–90) named the trend 'Japonisme'.

Japanese art had an appreciable effect on several European movements including Impressionism, Post-Impressionism and Art Nouveau. Many artists reinterpreted *Ukiyo-e* motifs, such as Pissarro with his wintry landscapes, Whistler's butterfly symbol, Monet's painting of Madame Monet in a kimono, and Van Gogh's replications of his own collection of Japanese prints.

Van Gogh,
The Courtesan,
1887

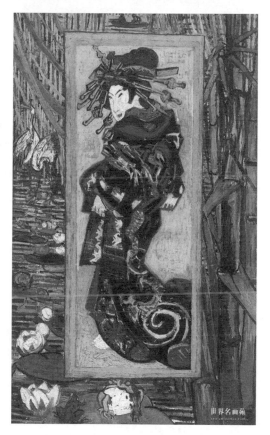

Monet

Usually seen as the leader of Impressionism, Claude Monet (1840–1926) was the most tenacious and prolific of the group. His influential ideas included an avoidance of black, a reduced palette of bright colours and short, broken brushmarks. Throughout a long career, his fascination with painting light as it appeared in fleeting moments and different weather conditions never diminished. As a central figure in the breakaway from accepted artistic conventions, he exhibited with the Impressionists each year from 1874 to 1879 and again in 1882. Early works included city scenes, gardens, beaches, landscapes, Parisians at their leisure and aspects of the modern, industrial world. In later life he created 'series paintings' – the same scene painted numerous times in changing light and different seasons. In 1883, he bought a house and garden at Giverny, where he created a huge garden, lily pond and Japanese bridge. He painted there almost exclusively for the last 20 years of his life. Many of his later works appear to advance towards abstraction and were a huge influence on succeeding artists.

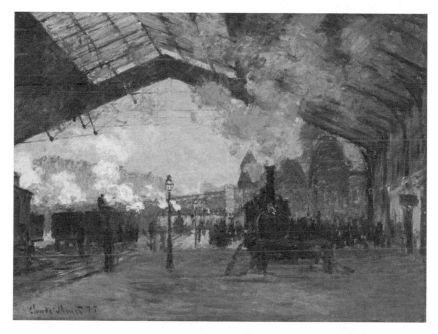

Monet, *Arrival of the Normandy Train, Gare Saint Lazare*, 1877

Rodin

One of the most influential artists of the late 19th and early 20th centuries was a sculptor, not a painter. Auguste Rodin (1840–1917) had traditional training and sought academic recognition, but was initially perceived as a rebel, and was rejected three times from the École des Beaux-Arts. After visiting Italy in 1875, he was inspired by the works of Donatello and Michelangelo, and on his return to France, he created *The Age of Bronze*, exhibited at the Paris Salon in 1877. In comparison with the idealized figures of prevailing Academic sculpture it caused great controversy for its realism – indeed, some thought it was cast from a living model – an illegal practice.

Yet once it was discovered that no underhand practice had taken place, Rodin became admired. He was commissioned to create various major projects for public institutions and became the pre-eminent French sculptor of the time. Expressive, dynamic and lifelike, his work later featured more unfinished surfaces to express even greater reality and movement.

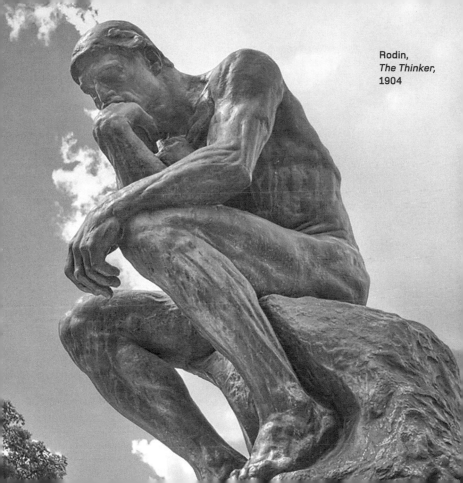

Rodin,
The Thinker,
1904

Neo- and Post-Impressionism

Post-Impressionism was a phase of creative experimentation from around 1880 to 1910, when some artists reacted against Impressionism's preoccupation with straightforward, superficial appearances. They included Paul Gauguin, Van Gogh, Toulouse-Lautrec, Cézanne and Georges Seurat. With no single style, Post-Impressionists expressed themselves in unnatural hues and distorted forms. Van Gogh and Gauguin used brilliant colours and shapes to convey their feelings, Cézanne used hatched brushmarks to depict structure, and Toulouse-Lautrec portrayed Parisian life in colourful, sinuous images.

The term 'Neo-Impressionism' was coined in 1886 by art critic Félix Fénéon (1861–1944) to describe the work of Seurat, Paul Signac and followers. Inspired by the colour theories of chemist Michel Eugène Chevreul (1786–1889) and others, they painted pictures in dots of pure colour, rather than mixing on their palettes. Seurat called it Divisionism, but it became better known as Pointillism.

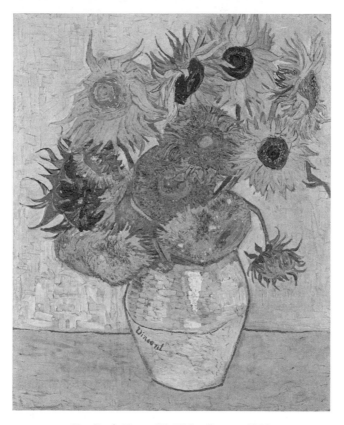

Van Gogh, *Vase with 12 Sunflowers*, 1888

Seurat and Signac

Moving on from the apparent spontaneity of Impressionism, Georges Seurat's (1859–91) structured, analytical system of painting, juxtaposing dots of pure colour across his canvases, altered the direction of modern art. Trained at the École des Beaux-Arts, Seurat copied Old Masters in the Louvre and was especially influenced by Rembrandt and Goya. After seeing the 1879 Impressionist exhibition, he recognized the possibilities of breaking with Academic tradition. He began studying colour theories, producing over 500 drawings in Conté crayon that explored tonal contrasts and soft contours. His large-scale work, *A Sunday Afternoon on the Island of La Grande Jatte* (1884–86) used his scientifically based innovations to create shimmering effects. In 1884, he helped to form the Societé des Artistes Indépendants and befriended Paul Signac (1863–1935). His dabs of pure colour inspired Signac, who abandoned the short brushstrokes of Impressionism and also began experimenting with Divisionism. After Seurat's early death, Signac continued painting in the vivid Divisionist style for the rest of his career.

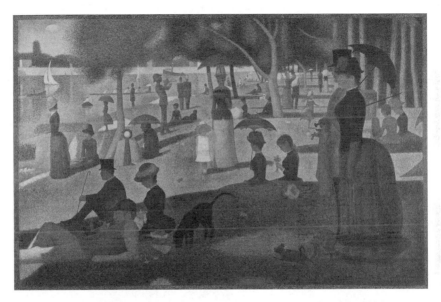

Seurat, *A Sunday Afternoon on the Island of La Grande Jatte*, 1884

Cézanne

One of the single most influential artists in the shaping of 20th-century art, Paul Cézanne (1839–1906) aimed to find a pictorial form that he believed would make sense of the world. In doing so, he changed the history of art. Both Matisse and Picasso called him 'the father of us all'.

For most of his life, Cézanne was misunderstood and his art ridiculed. Every year from 1864 to 1869, he submitted work to the Paris Salon, but was constantly rejected. Then he befriended the Impressionists and exhibited with them in 1874 and 1877, but although he went on painting expeditions with Pissarro, and for a while described himself as Pissarro's pupil, he was a solitary man, and soon moved back to his family home in Provence. There, he tried to work out his own methods by representing a sense of the structure of things, painting shapes and blocks of colour to show underlying forms. He evolved a technique of applying angled patches of paint using a restricted palette, and moved away from the single viewpoint that most artists traditionally depict.

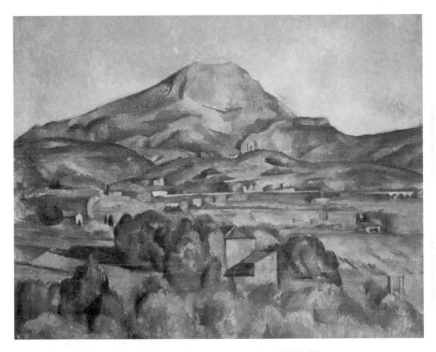

Cézanne, *Mont Sainte-Victoire*, 1885–95

Still life

Although still life has never been seen as the most important genre, it has often been the most realistically portrayed. The term derives from the Dutch *still-leven* ('inanimate objects'). Some ancient Greek and Roman frescoes and mosaics included *trompe l'oeil* ('fool the eye') depictions of plants and food. Early Christian and Byzantine art occasionally featured stylized and symbolic still life elements, and by the 15th century still life arrangements were included in some paintings to show the artist's skill.

Dutch Golden Age artists such as Steenwyck painted detailed, lifelike still lifes, which were bought by middle-class citizens. In Spain, artists such as Cotán and Velázquez painted *bodegóns*, or still lifes incorporated into domestic scenes. In France, still life became noticed through Chardin's work in the 18th century, and a century later, Cézanne used them to investigate structure. In the 20th century, artists such as Giorgio Morandi explored still life using various materials and methods, while Cubists and Pop artists particularly embraced the genre.

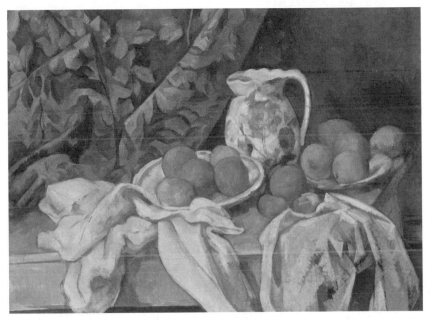

Cézanne, *Still Life with a Curtain*, c.1898

Symbolism

Reacting against what they perceived as the superficiality of Realism and Impressionism, Symbolists abandoned direct, literal representations in favour of implication, suggestion, spirituality, the imagination and dreams, aiming to evoke certain feelings and moods. The loosely organized movement began in the late 19th century, as artists, writers and poets emphasized their emotions, intellect, ideas and subjectivity, exploring subjects such as love, death, sin or disease, and used visual metaphors to represent them. It aimed to unite the material and the spiritual world, or as poet Jean Moréas (1856–1910) wrote in his Symbolist Manifesto of 1886: 'to clothe the idea in sensuous form'. Prominent Symbolist painters included Puvis de Chavannes (1824–98), Gustave Moreau (1826–98), Odilon Redon (1840–1916), Eugène Carrière (1849–1906) and Vilhelm Hammershøi (1864–1916). The movement began in France, but appeared almost concurrently in Russia, Belgium and Austria. Although comparatively short-lived, it exerted a strong influence on late-19th-century German art and on several 20th-century movements.

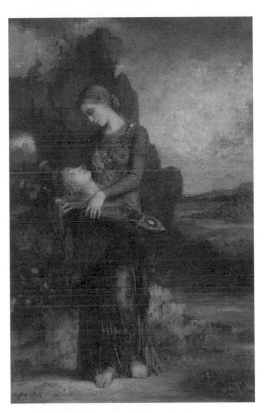

Moreau, *Thracian Girl Carrying the Head of Orpheus on his Lyre*, 1865

Gauguin

Famous for leaving his stockbroking job in Paris, abandoning his family and moving to Tahiti, Paul Gauguin (1848–1903), discarded all respectability to become an artist at the age of 35. Influenced by Pissarro, he participated in the last four Impressionist exhibitions, and during visits to Pont-Aven in Brittany developed a style he called Synthetism. In 1888–89, he worked briefly with Van Gogh in the South of France, but in 1891 he left France for Tahiti, where he produced many of his most famous paintings, sculptures and woodcuts. He spent most of the rest of his life in the South Seas.

One of the first artists to find inspiration in the art of primitive cultures, he invented a non-naturalistic painting style of strong outlines and bright, flat colour, combining influences from medieval stained glass and Polynesian, Buddhist, Asiatic, ancient Greek and folk art, to Impressionism and Realism. Both the Nabis and the Symbolist movement were shaped by his ideas, although he personally rejected the concepts of Symbolism.

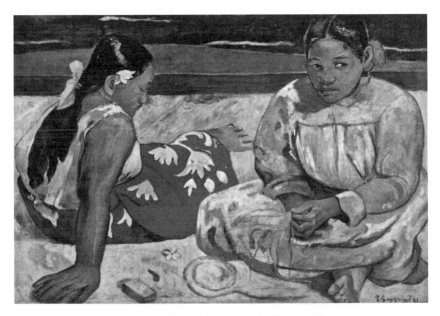

Gauguin, *Tahitian Women on the Beach*, 1891

Synthetism

In 1886 and 1888, Gauguin stayed at Pont-Aven and Le Pouldu in Brittany, where he mixed with younger artists including Émile Bernard (1868–1941), Louis Anquetin (1861–1932), Jacob Meyer de Haan (1852–95), Charles Laval (1862–94) and Paul Sérusier (1863–1927). Dissatisfied with the Impressionist obsession with light and objective representations of nature, Gauguin began using colour to create expressive effects.

Bernard and Anquetin were developing a style that became known as Cloisonnism after medieval Cloisonné enamelling. It inspired Gauguin, who in 1888 painted *The Vision After the Sermon: Jacob Wrestling with the Angel*. With areas of vivid colour outlined in black, the painting was also inspired by Japanese woodcuts, colour theories and Symbolism. Gauguin called his new approach Synthetism, referring to the flat colours and distorted shapes synthesizing with the artist's intention or the mood of the subject. By infusing notions as memory, imagination and emotion, he believed that Synthetism was more meaningful than Impressionism.

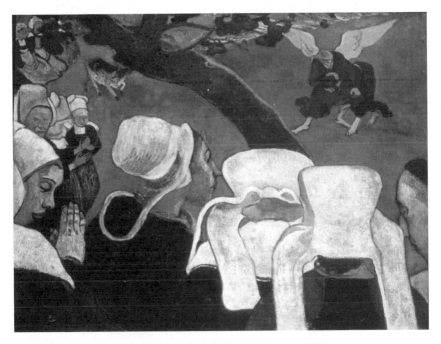

Gauguin, *The Vision after the Sermon*, 1888

The Nabis

In 1888, a number of painters in Paris formed a secretive group they called the Nabis (Hebrew for prophets). Led by Paul Sérusier, they included Pierre Bonnard (1867–1947), Édouard Vuillard (1868–1940) and Maurice Denis (1870–1943). Denis summed up their beliefs: 'A picture, before being a warhorse, a nude, or some kind of story, is essentially a flat surface covered with colours arranged in a certain order.'

During a painting lesson with Gauguin in 1888 in the Bois d'Amour on the bank of Brittany's Aven River, Sérusier learned to intensify colour and simplify form. He took the resulting painting – a small, near-abstract landscape of patches of simplified, non-naturalistic colour – back to the Académie Julian in Paris where the work astonished his fellow students Bonnard, Denis and Vuillard. They nicknamed it *The Talisman*, after a secret, magical object, and it inspired them to form the Nabis, following Gauguin, and making their images of nature personal and symbolic. They exerted a major influence on other art produced in France at the time.

Sérusier, *The Talisman*, 1888

Naïve art and Primitivism

Primitivism was not a movement, more of a general desire to return to the less complicated art styles of some earlier cultures. Often characterized by a childlike simplicity in subject matter or technique, Primitivism grew from a European belief that non-Western and folk art was less civilized than modern, urban art. It was a romantic, nostalgic view, but as the sculptor Henry Moore (1898–1986) noted, the term implies lack of skill on behalf of the maker, but actually displays Western ignorance of the styles, beliefs and approaches of other societies.

Primitivism emerged in the simplified drawings and bold colours of Synthetism, but especially in Gauguin's first Tahitian paintings. In the 1890s, Henri Rousseau (1844–1910) was one of the first to paint in a naïve (childlike) style. By the early 1900s, several others were also exploring the naïve, simplifying their imagery to express innocence, originality and purity. These included Emil Nolde (1867–1956), Max Pechstein (1881–1955), Matisse, Modigliani, Picasso and sculptors Jacob Epstein (1880–1959) and Constantin Brancusi.

Rousseau, *Tiger in a Tropical Storm (Surprised!)*, 1891

Toulouse-Lautrec

As famous for his physical deformities and colourful life in Montmartre as for his elegant and provocative images, French painter, printmaker, draughtsman and illustrator Henri de Toulouse-Lautrec (1864–1901) is among the best-known Post-Impressionists. An aristocrat whose legs stopped growing after two adolescent riding accidents, he turned to painting, after being shunned by his own social class. Living among the nightclubs, cabarets and brothels of Paris, he captured the movement, colour and exuberance of this seedy side of life.

Following Japanese print designs, Lautrec's flattened colours and angled compositions revolutionized the art of the poster and created a new form of popular art. His rapid drawing skills expressed a sense of immediacy and tension, and his paintings and prints featured vivid, unexpected colours and combinations, energetic brushstrokes and delineated outlines and contours, using paint thinned with turpentine, expressing the spontaneity and spirit of the people around him, but never judging them.

Toulouse-Lautrec, *At the Moulin Rouge*, 1892–5

Printmaking

Prints allow artists to reproduce numerous copies of one image. They are made using three main methods, each with several variations. These are relief printing, where the background is cut away or incised and a raised image takes the ink; intaglio, from the Italian *intagliare* ('to engrave'); and planographic, or printing from flat surfaces, as for example, in lithography, which works on the basis that water does not mix with oil.

Woodcut printing was invented in China in the fifth century but did not become popular in Europe until the 15th, when it was used particularly masterfully by Dürer. In the 17th and 18th centuries Rembrandt and Goya produced powerful etchings, and Velázquez and Turner were among several artists whose work became well known abroad through prints of their paintings. After Japanese *Ukiyo-e* prints gained popularity in the later 19th century, some of the most renowned artists such as Toulouse-Lautrec, Gauguin, Matisse and Andy Warhol used various printing techniques, including lithography and screen-printing.

Rembrandt, *Self Portrait with Cap Pulled Forward*, c.1631

Van Gogh

Before taking up painting at 27, Vincent van Gogh (1853–90) worked as an art dealer, a teacher and an evangelist. He is now generally considered the greatest Dutch painter after Rembrandt and a huge influence on the development of modern art. Influenced at first by Rembrandt, Rubens and Gustave Doré (1832–83), then later by Millet, Japanese prints, the Impressionists and some of the Post-Impressionists, his art is linked to several movements, including Post-Impressionism, Expressionism and Symbolism. In ten years, he produced more than 2,000 artworks, including 864 paintings and 1,200 drawings and prints. Most of his best-known works were created in the final two years of his life.

Initially, he painted with a dark palette inspired by Rembrandt, but after living and working with Gauguin for two months in 1888–89, he developed an expressive, swirling style of thick impasto paint and brilliant colours that was both instinctive and personal. He often used paint squeezed straight from the tube onto his canvases, and distorted form and colour to express his feelings.

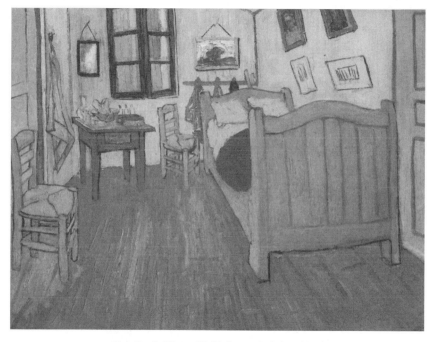

Van Gogh, *Vincent's Bedroom in Arles*, 1888

Colour

Colour is among the most important elements of art. Early natural pigments from plants and minerals were limited, inconsistent and often costly, but after 1704, brighter and cheaper synthetic pigments were developed. In 1810, Johann Wolfgang von Goethe (1749–1832) wrote about colour as an emotional force. Following this, Turner created several compositions using just primary colours: red, yellow and blue, with white and black. Later, Mondrian did the same, but profoundly differently.

Following Chevreul's 1839 book *The Law of Simultaneous Colour Contrast*, Delacroix experimented with simultaneous contrast; the theory that two adjacent complementary colours appear unusually bright. Complementaries are opposites on a colour wheel, that is: red-green, blue-orange, and yellow-violet. In the early 20th century, Matisse and the German Expressionists painted with vivid, unnatural colours, and Klee and Wassily Kandinsky explored unexpected colour relationships. Yves Klein, David Hockney and Joan Miró also exploited vibrant synthetic pigments.

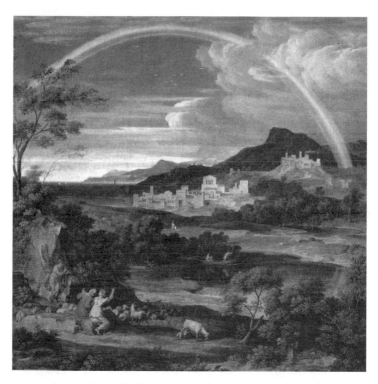

Joseph Anton Koch, *Heroic Landscape with Rainbow*, 1805

Art Nouveau

An influential art and design movement that emerged in the final decades of the 19th century and ended with the First World War, Art Nouveau developed across Europe and America in provincial towns as much as in capital cities. A conscious attempt to create a unique and modern form of expression that evoked the spirit of the age, it manifested in painting, illustration, sculpture, jewellery, metalwork, glass, ceramics, textiles, graphic design, furniture, architecture, costume and fashion.

Art Nouveau evolved directly from the Arts and Crafts movement, drawing on influences including Celtic art and design, the Gothic Revival, the Rococo, Aestheticism, Symbolism and Japonisme. Aiming to raise the status of craft and decorative arts to that of fine art, practitioners endeavoured to produce 'total works of art' or *gesamtkunstwerk*, in which every aspect was coordinated. Artists, designers and architects also aimed to harmonize with the natural environment, using flowing forms, sinuous lines and asymmetry, conveying an impression of movement.

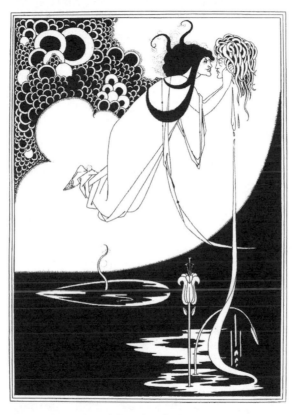

Beardsley, *The Climax*, 1893

Vienna Secession

By 1897, Vienna was one of the largest cities in Europe, but its citizens were stifled by bureaucracy and old-fashioned attitudes to art. The only exhibition space was the Vienna Künstlerhaus, run by a conservative committee. A group of progressive young artists, designers and architects including Otto Wagner (1841–1918), Josef Hoffmann (1870–1956), Joseph Olbrich (1867–1908), Gustav Klimt and Koloman Moser (1868–1918) resigned from the Association of Austrian Artists to embrace new creative ideas, aiming to synthesize all the arts (mirroring with the aims of Art Nouveau). Announcing their aims, they said: 'We do not recognize any difference between great and minor art, between the art of the rich and that of the poor. Art belongs to all.'

Klimt became first president of this radical club, the 'Vienna Secession'. They published a periodical, *Ver Sacrum* ('Sacred Spring' in Latin), and constructed a new building as an exhibition space. Similar groups appeared around the same time in several European cities, but Vienna's was to be the most influential.

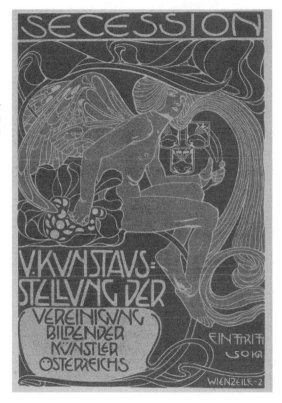

Moser, poster for
Fifth Vienna Secession
exhibition, 1899

Klimt

Criticized for sensuality and eroticism in his time, but also highly admired, Austrian artist Gustav Klimt (1862–1918) produced highly ornamental paintings rich in Symbolist elements. His primary subject was the female form – images of pregnancy, motherhood and ageing, as well as portraits of society women – but he also painted stylized allegories and landscapes. A pivotal figure in Art Nouveau and the Vienna Secession, his later work was particularly expressive and vibrant. Inspired by influences from Impressionism, Symbolism and Dürer to Japanese, Classical Greek, Byzantine and ancient Egyptian art. His unique approach mixed mosaic-like flat patterns with a detailed, realistic, three-dimensional style.

After Klimt's paintings of c.1900 for the University of Vienna's Great Hall were denounced as pornographic, he refused further public commissions. For the next decade, he created jewel-like paintings featuring gold leaf and other rich embellishments. The period became called his 'Golden Phase' – although the content of some works continued to shock, it also attracted admiration.

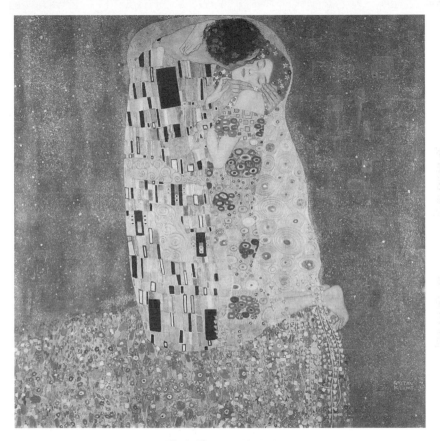

Kllmt, *The Kiss*, 1908–9

Ashcan School

Developing from American Realism, several artists began painting daily life in poor neighbourhoods, notably in New York where they lived between 1896 and 1904. With a spontaneous, unrefined style, they created harsh images of poverty and became known as the Ashcan School. They included Robert Henri (1865–1929), John Sloan (1871–1951), Everett Shinn (1876–1953), George Luks (1867–1933), William Glackens (1870–1938) and George Bellows (1882–1925). Some had met while studying with the Realist Thomas Anshutz (1851–1912) at the Pennsylvania Academy of Fine Arts, while others met working as illustrators in Philadelphia newspaper offices. With Parisian training and a bold, painterly style, Henri was the School's leader.

Most painted vulnerable people using a direct style with dark tonal contrasts and gestural brushwork. Edward Hopper (1882–1967) is often linked with them, but he said that unlike Ashcan art, his work did not show rough elements of life, only aspects of America that were not always seen.

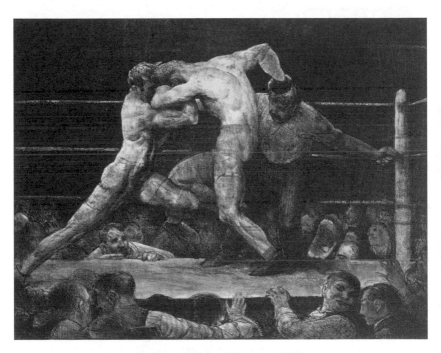

Bellows, *A Stag at Sharkey's*, 1917

Modernism

Following the First World War and the Russian Revolution, many in the West anticipated an era of technological, social, economic and artistic developments that would improve life for all. This utopian attitude had started with the Arts and Crafts movement and Realism, but gathered momentum with a plethora of new styles, attitudes and approaches appearing in quick succession, as artists and designers sought new forms of expression.

Rather than a style, Modernism was a loose collection of shared principles, including rejection of history and applied ornament; a preference for abstraction; and a belief that technology and design could transform society. It emerged in many areas, including architecture, literature, art and design. The architects Le Corbusier (1887–1965) and Frank Lloyd Wright (1867–1959), for instance, believed that new technology rendered old styles of building obsolete. Similarly, Modernist designers rejected superficial decoration for geometric shapes and plain materials. In Germany, the Bauhaus School epitomized Modernist ideals.

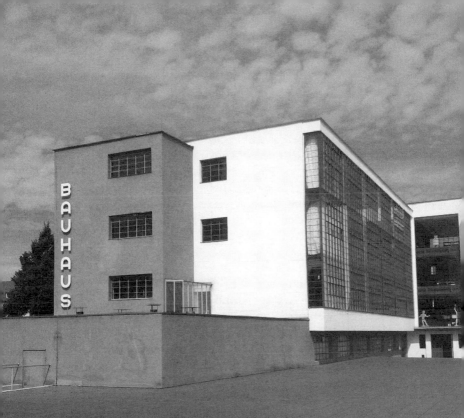

Walter Gropius, Bauhaus building, Dessau, 1925

Munch

Norwegian artist and forerunner of Expressionism, Edvard Munch (1863–1944) produced paintings and prints that portray psychological and emotional themes with fluid lines and bold colours, expressing his experiences of bereavement, sickness, rejection, despair, loneliness and depression. His early paintings were naturalistic, but after visiting Paris in 1885, he was inspired by the Impressionists to try new colours and brushstroke techniques. During a second Parisian visit in 1889–90, he studied in the studio of Léon Bonnat (1833–1922), and became influenced by the Neo-Impressionists, Van Gogh, Gauguin and Toulouse-Lautrec. Changing his palette, he used colours to convey emotion, and also followed ideas he had seen in Symbolist paintings. In 1892, he exhibited his new, expressive works at Germany's Verein der Berliner Künstler, where they provoked fierce controversy. Yet he continued working in his sketchy, unfinished style to reveal his intensely personal feelings about such things as isolation, sexuality, death and uncertainty, in an emotive way that was immediately understood by viewers.

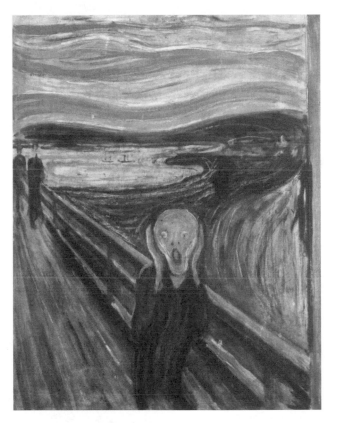

Munch, *The Scream*, 1893

African art

Some of the oldest art ever discovered was made in the vast continent of Africa. Produced for religious reasons, celebrations, initiations, harvesting and war preparation, much of it represents spirits and ancestors. For about a thousand years from c.1070 BCE, the Nubians of Kush produced monumental sculpture, while in northern Nigeria between 1000 BCE–300 CE, the Nok people created angular, elongated clay figures. The Chokwe of central Africa produced detailed carvings and sacred *chikunga* masks in the 15th century, and from the 16th to the 17th century, the Yombe in western central Africa created symbolic *nkisi nkondi* figures. In the 17th to 19th century, the Bamana, also in western central Africa, produced pottery, sculpture and wrought-iron figures, and since the late 19th century, the Kota of western central Africa have created abstracted figurines in wood and copper. *Fang* masks, made in Cameroon, Equatorial Guinea and Gabon, represent the spirits of ancestors. Expanding trade generated exchanges of ideas, and in the early 20th century, African styles had a powerful influence on European artists.

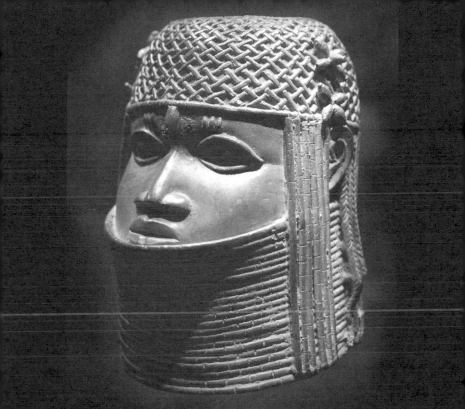
Benin bronze head, c. 19th century

School of Paris

Paris in the early 20th century was a thriving centre of artistic activity, attracting artists, dealers and collectors from all over the world. Many new movements, including Fauvism, Cubism and Surrealism, emerged and were exhibited first in Paris. Collectively, they became loosely termed the School of Paris (École de Paris). Foreign artists mostly lived in Montmartre and then Montparnasse. Picasso was a leading figure, and another Spaniard living here was Joan Miró (1893–1983), a pioneer of Surrealism. The Italian Modigliani (1884–1920), famous for elongated sculptural figures, initially worked here with Romanian sculptor Brancusi. Chaim Soutine (1893–1943) arrived from Lithuania in 1913 to create pictures infused with angst and personal expression. Russian Marc Chagall (1887–1985) created dreamlike images, unrealistic perspectives and scales. Also classed as part of the School of Paris were some outstanding French artists, including Matisse, Georges Braque, André Derain (1880–1954), Bonnard, and Robert Delaunay. These vibrant collaborations and ideas came to an end with the outbreak of the Second World War in 1939.

Chagall, *I and the Village*, 1911

Kokoschka and Schiele

Oskar Kokoschka (1886–1980) was an Austrian artist, poet and playwright who became known for his intense, expressive portraits and landscapes. In 1908, while studying at Vienna's School of Arts and Crafts, he wrote a play, *Murderer, Hope of Women*, and exhibited at the Kunstschau exhibition. The violence of his images made the art particularly controversial, and he was dismissed from the School. He went on to become one of the leading exponents of Expressionism, with richly coloured, gestural, psychologically probing portraits and dramatic cityscapes.

Strongly influenced by Klimt and Kokoschka, Egon Schiele (1890–1918) was a superb draughtsman, and painted sexually intense subjects with a raw approach to brushwork and colour. His twisted body shapes and expressive contours make him, like Kokoschka, an early exponent of Expressionism. His probing self-portraits, gaunt figures and Art Nouveau cityscapes became more complex and contorted, deliberately disquieting, and horrified many. Yet he became successful in certain circles before his untimely death.

Schiele, *Seated Woman with Bent Knee*, 1917

Fauvism

In 1905, Matisse, Derain, Braque, Kees van Dongen (1877–1968), Raoul Dufy (1877–1953) and Maurice de Vlaminck (1876–1958) held a group exhibition in Paris, at the fairly new Salon d'Automne. Their deliberately crude and vividly colourful canvases, with free brushwork and broken lines, outraged critics, and the moniker 'Les Fauves' (Wild Beasts) was given to them in contempt. Also ridiculed and derided by the public, their absence of tone, non-naturalistic depictions and colours seemed absurd and illogical.

Fauvism was a development of Post-Impressionism: the artists involved were all inspired by Cézanne's exploration of solidity, Van Gogh's angled and expressive brushstrokes, and his and Seurat's use of pure, unmixed colours and simultaneous contrast. Abandoning theories and lifelike representations, the artists intentionally focused on colours and marks, embracing the flatness of their canvases and vivacity of their paint. The images still loosely represented life, but distorted it to explore the effects of colours and marks and create a new, free visual language.

Derain, *Madame Matisse in Kimono,* 1905

Matisse

One of the most innovative and influential artists of the 20th century, and a pivotal figure in the development of modern art, Henri Matisse (1869–1954) is often referred to as the 'master of colour'. In 1905, he became leader of the short-lived Fauvist movement, using explosive colours and expressive brushwork. His diverse influences included Poussin, Manet, Cézanne, Gauguin, Van Gogh, Seurat, Signac, the Orientalists and the colours and shapes of the South of France, Spain, North Africa and Islamic art.

In 1906, he visited Algeria and Morocco, where the radiant light, exotic surroundings and Moorish architecture inspired him. After visiting Seville in 1911, he began spending time in Collioure, Paris and Nice. His mastery of colour enabled him to evoke feelings of happiness. He said: 'What I dream of is an art...devoid of troubling or depressing subject matter...which could be for every mental worker, for the businessman as well as the man of letters, for example, a soothing, calming influence on the mind, something like a good armchair which provides relaxation from physical fatigue.'

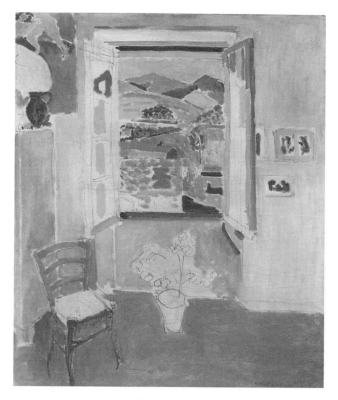

Matisse, *The Open Window,* 1911

Expressionism

Around the same time that the Fauves produced their vibrant, expressive paintings in France, German artists also began producing passionate, energetic and non-naturalistic art. Expressionism, as it came to be called, developed from a feeling of unrest in the country, and emerged as powerful, candid and personal depictions of individual artists' viewpoints. Without any one, specific style, the movement was subjective and impassioned.

The word Expressionism was used to describe the ideas that some artists were portraying with graphic, often brutal and distorted images. They used colours and compositions for emotional significance, aiming to convey their feelings rather than the objective portrayals of Impressionism. Expressionists admired movements such as Symbolism and artists including Van Gogh, Munch and James Ensor (1860–1949). Although it appeared almost simultaneously in various cities across Germany, it was not the product of one unified group, and many of those described as Expressionists did not know each other, or even accept the name.

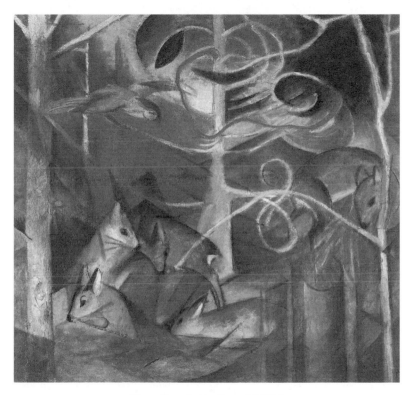

Marc, *Deer in the Forest I*, 1913

Die Brücke

In 1905, in Dresden, four German artists Fritz Bleyl (1880–1966), Erich Heckel (1883–1970), Ernst Ludwig Kirchner (1880–1938) and Karl Schmidt-Rottluff (1884–1976) formed Die Brücke ('The Bridge'). Later, others joined them, including van Dongen, Nolde, Max Pechstein and Otto Müller (1874–1930). Aiming to challenge and confront traditionally accepted styles of art, which by then included Impressionism and Post-Impressionism, their modern, urban subject matter, landscapes and figures also expressed radical political and social views. Like the Fauves, Die Brücke artists were fascinated by Primitivism, believing that their art would create a bridge between accepted art and more recent works. Inspired by the past as well as the present, they admired Dürer, Grünewald and Cranach the Elder, but used bright colours and unsophisticated techniques. Die Brücke held their first exhibition in 1906, publishing a group manifesto. Most members painted in a deliberately agitated, emotional style, exaggerating brilliant colours and shapes to emphasize particular aspects of each image.

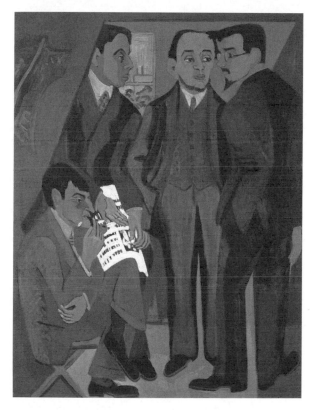

Kirchner, *Group of Artists*, 1926–7

Der Blaue Reiter

In 1911 in Munich, another group of artists formed Der Blaue Reiter ('The Blue Rider'). They included Wassily Kandinsky, Franz Marc (1880–1916), Paul Klee, Alexej von Jawlensky (1864–1941) and Auguste Macke (1887–1914). The name derived from a Kandinsky painting of 1903, used on the cover of their 1912 almanac, which contained essays on art by both Kandinsky and Marc. Both artists admired the power and beauty of horses, and both believed in the mystical significance of the colour blue. Drawing inspiration from Van Gogh, Gauguin, Munch and Primitivism, they believed they could express spiritual values through colour and abstraction.

Kandinsky led the group, and said that simple shapes and bold colours can portray moods and feelings, eliminating the need for subject matter. All the artists painted simplified, lively, colourful images, conveying their feelings about the world. But when the First World War broke out, Marc and Macke were drafted into military service and killed, while Kandinsky, von Jawlensky and other Russian artists who had joined them, had to return home.

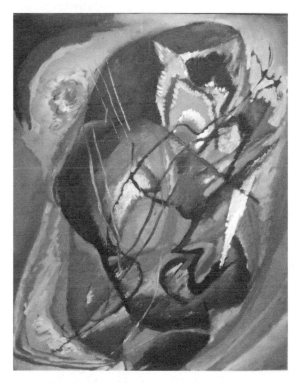

Kandinsky, *Untitled Improvisation III*, 1914

Picasso

Probably the most influential artist of the 20th century, Pablo Ruiz y Picasso (1881–1973) was a painter, draughtsman, sculptor, printmaker, ceramicist and set designer. In a career that lasted over 75 years, he produced more than 2,000 works and changed the course of art. A child prodigy in Spain, he painted at first with great realism. In 1900, at the age of 19, he moved to Paris and, over the next decade, experimented with different theories, techniques and ideas. While many of his later styles have not been named, the earliest included his Blue Period (1901–04), Rose Period (1904–06), African-influenced Period (1907–09), Analytical Cubism (1909–12) and Synthetic Cubism (1912–19). His distorted figures included Neoclassical and Metamorphic phases in the 1920s. He continued to make developments in various media, each original and powerful. He co-founded Cubism, invented constructed sculpture, introduced collage into fine art, became involved in Surrealism and created emotive works capturing the horrors of war, most notably the German Luftwaffe's bombing of Guernica in the Spanish Civil War.

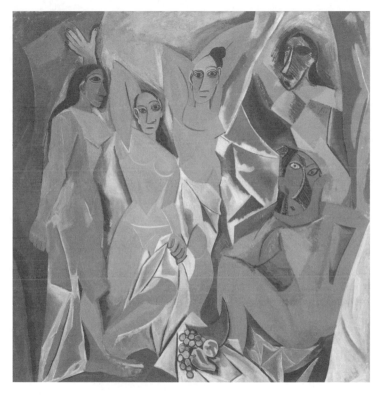

Picasso, *Les Demoiselles d'Avignon*, 1907

Cubism

One of the most influential art movements, Cubism was invented in 1907–08 when Picasso and Georges Braque (1882–1963) broke with the European traditions of creating illusions of space from fixed viewpoints. Other Cubists included Albert Gleizes (1881–1953), Jean Metzinger (1883–1956), Henri Le Fauconnier (1881–1946), Fernand Léger (1881–1955) and Juan Gris (1887–1927). The movement began with Picasso's *Les Demoiselles d'Avignon*, 1907, which showed Cézanne's influence, particularly his late works, as well as African masks and Spanish sculpture.

By painting objects from several viewpoints at once, the artists aimed to show three-dimensional forms on flat canvases, without attempting to create illusions of depth. The name Cubism derived from a comment by critic Louis Vauxcelles (1870–1943), though neither Braque nor Picasso used it. Analytical Cubism, consisting of planes and lines in blacks, greys and ochres, lasted from 1908 to 1912. Synthetic Cubism lasted from *c.*1912–14, and featured brighter colours and elements of collage.

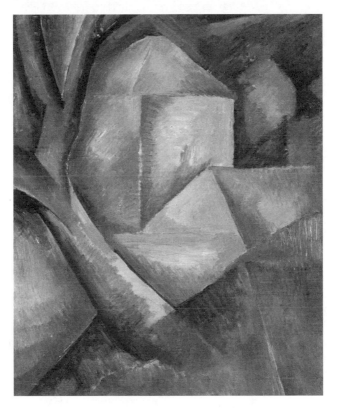

Braque, *Houses at L'Estaque,* 1908

Futurism

The most important Italian avant-garde art movement of the 20th century, Futurism celebrated machines, speed, violence and modernity. From 1909 to 1918, its artists determined to destroy Italian traditions and create a new art that embraced movement, technology and energy. Most believed the machine age would improve everyone's lives. In 1909, the poet and editor Filippo Tommaso Marinetti (1876–1944) wrote a Futurist manifesto, praising youth, machines, power and speed, and declaring he would destroy art galleries and museums, liberating Italy from its past.

The Futurists first exhibited in Milan in 1911, and later in various other European cities, creating a stir in each. Futurists such as Umberto Boccioni (1882–1916), Carlo Carrà, Gino Severini (1883–1966), Giacomo Balla (1871–1958) and Antonio Sant'Elia (1888–1916) adopted elements of Post-Impressionism, Symbolism, Divisionism and Cubism. In turn, Futurism influenced Art Deco, Constructivism, Surrealism and Dada. Enthusiasm for technology led them to naively celebrate the start of the First World War.

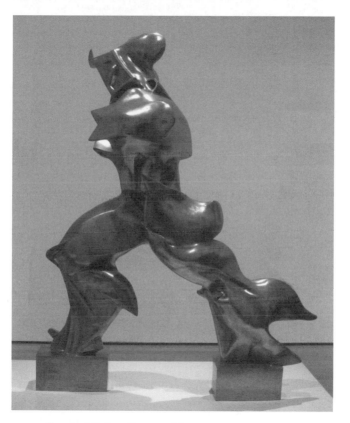

Boccioni, *Unique Forms of Continuity in Space*, 1913

Orphism and Rayonism

Developed around 1912 by Robert Delaunay (1885–1941) and Sonia Delaunay (1885–1979), Orphism or Orphic Cubism, was inspired by Cubism, Fauvism, Seurat, Signac and Chevreul. It was named by the French poet Guillaume Apollinaire (1880–1918) after Orpheus, the poet and singer of ancient Greek mythology. Robert Delaunay was interested in the geometric fragmentation of Cubism, but whereas Cubists subdued colour, he used bright colours and abstracted shapes, and deployed Chevreul's theory of Simultaneous Contrast to make his colours appear bright.

Rayonism was developed in Russia in 1911 by Mikhail Larionov (1881–1964) and Natalia Goncharova (1881–1962) after they attended lectures on Futurism by Marinetti. It synthesized Cubism, Futurism and Orphism, creating abstract images based on the effects of light on landscapes or cityscapes. The artists created the name from their use of dynamic lines of contrasting colour to represent criss-crossing rays of light. They debuted their work at the 1913 'Target' exhibition in Moscow, but had all abandoned it by 1915.

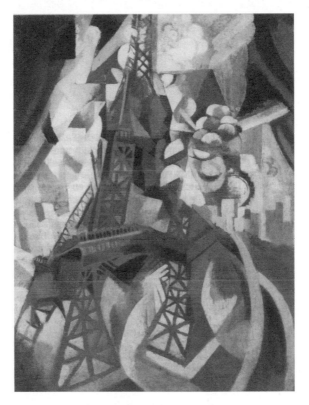

Delaunay, *The Red Tower*, 1911–12

Bloomsbury Group

In 1905, a group of artists, writers and intellectuals began meeting at the home of the artist Vanessa Bell (1879–1961) and her writer sister Virginia Woolf (1882–1941) in Bloomsbury, London. Main members of the Bloomsbury group included novelist E.M. Forster (1879–1970), art critic Clive Bell (1881–1964), painters Bell and Duncan Grant (1885–1978), economist John Maynard Keynes (1883–1946), and writers Leonard Woolf (1880–1969) and Lytton Strachey (1880–1932).

Except Duncan Grant, the male Bloomsbury Group members were educated at either Trinity or King's College, Cambridge. The Bloomsbury group had no formal philosophy, but was united in a belief in the importance of the arts and by a rejection of the restrictions of Victorian society. Unusually for the period, they were all open-minded about sexual matters. After they were joined by Roger Fry in 1910, the artists in the group began producing adventurous, richly coloured and patterned abstract and figurative paintings, which became known as Bloomsbury Style.

Grant, *Angelica Playing the Violin*, 1934

Vorticism

Aiming to create art and poetry that expressed the dynamism of the modern world, the British Vorticist movement combined Cubist fragmentation with geometric imagery that derived from machines and the urban environment and bordered on abstraction. The group was founded in 1914 by Wyndham Lewis (1882–1957), but ended the following year. It held one exhibition and produced two issues of the magazine *BLAST*, containing their manifesto and deriding what Lewis saw as the flimsiness of British art and culture. Vorticists included Lawrence Atkinson (1873–1931), Jessica Dismorr (1885–1939), Cuthbert Hamilton (1885–1959), William Roberts (1895–1980), Helen Saunders (1885–1963), Edward Wadsworth (1889–1949), Jacob Epstein and Henri Gaudier-Brzeska (1891–1915). American poet Ezra Pound (1885–1972) was also involved, naming the movement after the notion of a vortex or whirlpool of energy: Vorticist works represent modern life in splintered, angled lines, drawing viewers' eyes into the centre of each work. David Bomberg (1890–1957) was not formally a member of the group, but worked in a similar, angular style.

Gaudier-Brzeska, *Self-Portrait,* 1913

Abstract art

Art of various cultures ranging from the Celtic to Islamic, has often featured abstract forms, but purely non-representational art did not emerge in the West until the 20th century. Several late-19th- and early-20th-century avant-garde artists emphasized colour, shape and visual sensations to impart emotions, but usually included some sort of representation.

From 1910-11, Kandinsky abstracted and distorted elements in his paintings, while simultaneously, Piet Mondrian (1872–1944) painted *The Grey Tree*, transforming a tree into abstract shapes and patterns. Meanwhile, in Stockholm in 1906, Hilma af Klint (1862–1944) created completely abstract paintings, combining shapes and dynamic brushstrokes in a series called *Primordial Chaos*. In 1912, Kandinsky published *On the Spiritual in Art*, arguing that colour and form can communicate without referencing the material world. By 1915-17, several more artists, including Malevich and Mondrian produced completely abstract art, and it became an important part of several later movements.

Mondrian, *The Grey Tree,* 1911

Kandinsky

The achievements of Russian Wassily Kandinsky (1866–1944) changed the path of art. His explorations of colour, shape and abstraction evolved from his synaesthesia – the capacity to 'see' sound and 'hear' colour – and his study of Theosophy, a system of beliefs that explore divine meanings and spirituality. To spread his ideas, Kandinsky wrote, taught and started art movements and groups, moving from Russia to Germany where he co-founded Der Blaue Reiter and later taught at the Bauhaus from 1922 to 1933.

Influenced by Russian folk art, Art Nouveau, Impressionism, Post-Impressionism, Fauvism and music, Kandinsky moved increasingly towards abstraction, based on intellectual ideas rather than an instinctive approach. He began distorting images, using bright unnatural colours, obscuring the subject matter and ultimately discarding it altogether, with colour, shape and a sense of dynamism taking its place. He rigorously planned compositions to evoke his convictions in art's ability to regenerate the world, and colour's power to provoke psychological responses in viewers.

Kandinsky, *Composition IV,* 1911

Suprematism

In 1915 in Russia, Kazimir Malevich (1878–1935) produced his first painting of a large black square on a white background, marking the beginning of the movement known as Suprematism. He perceived his works – rectangles, lines and circles in limited colours, emphasizing the shape and flat surfaces of his canvases – as the ultimate balance of positive and negative, superior to all past art. Inspired partly by Cubism and Futurism, and also by his spiritual beliefs, he believed pure abstraction had great power and would give viewers 'the supremacy of pure feeling'. The purity of the colours and forms were intended to encourage viewers to contemplate deeper ideas than superficial appearances.

The first Suprematist exhibition, held in St Petersburg in 1915, included 35 of Malevich's paintings. In 1927, he published *The Non-Objective World*, a book that became extremely important in the development of abstract art. Malevich felt Suprematism was well suited to post-revolutionary Russia, but despite early support, the Communist authorities later attacked the movement.

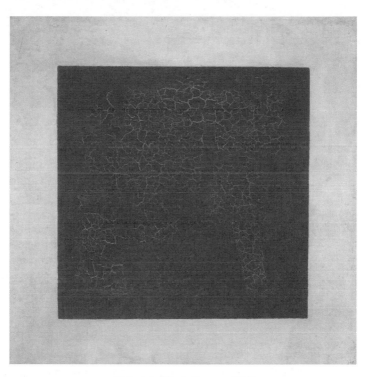

Malevich, *Black Square*, 1915

Constructivism

Borrowing ideas from Suprematism as well as Cubism and Futurism, Constructivism developed in about 1917 in Russia, just as the Bolsheviks came to power. It was the last and most influential modern art movement to emerge in Russia, and involved a careful technical analysis of modern materials, aiming to assist the development of mass production for the Communist society. Ultimately, however, it failed to make the leap from artists' studios to factories, partly because of the Bolshevik regime's growing hostility to avant-garde art. Like Suprematism, Constructivism focused on geometric shapes and forms. It was intended to be functional and straightforward, and to apply one consistent style across painting, design and architecture. Central to the movement was the aim of discarding traditional creative concerns about composition, replacing it with 'construction'. Leading Constructivists included Vladimir Tatlin (1885–1953), Alexander Rodchenko (1891–1956), El Lissitzky (1890–1941) and Naum Gabo (1890–1977). By the mid-1920s, the movement was losing popularity, but it continued to inspire artists in the West.

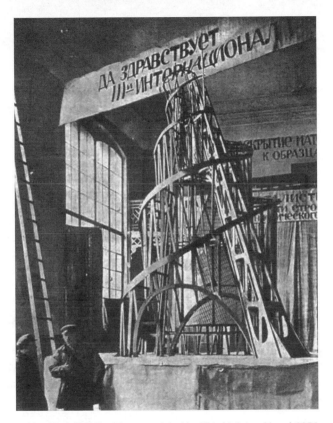

Tatlin, Model of the *Monument to the Third International*, 1921

De Stijl/Neo-Plasticism

In 1917 in the Netherlands, Mondrian, Theo van Doesburg (1883–1931) and Bart van der Leck (1876–1958) formed a group with some other artists, designers and architects. De Stijl ('The Style') intended to create the most refined lines, shapes and forms possible, simplifying the elements of paintings, designs and buildings, paring everything down to simple, uncluttered contours and minimal colours. Mondrian, the most original of the group, aimed to develop a new 'visual language' that everyone could appreciate, expressing spiritual balance and universal rhythms.

Influenced by Theosophy (which taught that a person's thoughts generate coloured auras around them), Mondrian set out his theory in a series of articles in the periodical *De Stijl*. For him, yellow symbolized the sun's energy, blue suggested the universe, and red represented the solidity of the Earth. Horizontal lines are feminine and vertical lines are masculine. He called his abstract style Neo-Plasticism, and used just the three primary colours and grids of black vertical and horizontal lines on a white ground.

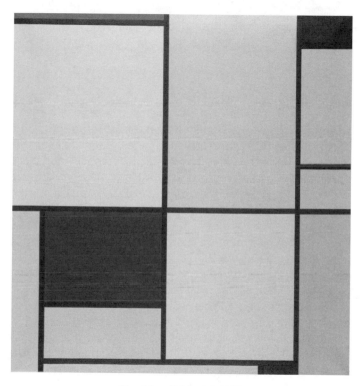

Mondrian, *Tableau 1,* 1921

Purism

Between 1918 and 1925, a new movement was developed in France by the painter Amédée Ozenfant (1886–1966) and the architect and painter Le Corbusier (Charles-Édouard Jeanneret). Feeling that Cubism had lost its original decisiveness and purity, they proposed a kind of austere painting that stripped objects of detail. Attempting to create a timeless, classical quality, Purism embraced new technologies and the modern machine age.

The two artists wrote about their ideas in a 1918 book, *Après le Cubisme*, and from 1920 to 1925 published a magazine *L'Esprit Nouveau*, exploring contemporary art, promoting Purism. They also presented ideas about architecture and town planning, denouncing past styles. A Purist manifesto stressed the importance of clarity, serenity and economy of means. Purism reached a climax in Le Corbusier's 1925 *Pavillon de l'Esprit Nouveau* at the International Exposition of Decorative and Industrial Arts in Paris, where work was exhibited by him, Ozenfant and the Cubists Léger, Gris and Jacques Lipchitz (1891–1973).

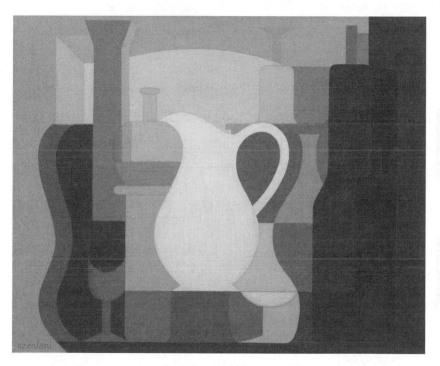

Ozenfant, *The White Pitcher*, 1925

American Modernism

Retrospectively called American Modernism, art produced in the United States during the fast-paced period between c.1910 and 1950 involved numerous ideas, experiments and explorations. Early artists under this umbrella term, such as Edwin Dickinson (1891–1978), Arthur Dove (1880–1946) and Georgia O'Keeffe (1887–1986), used nature as a starting point.

In 1913, the Armory Show in New York City was the first large display of modern art in America. With some 1,300 works of art by over 300 avant-garde European and American artists, it was ridiculed by press and public, but inspired many artists, who began exploring different techniques and modes of expression. Various groups formed and movements developed, including the Ashcan School; the Stieglitz circle led by photographer Alfred Stieglitz (1864–1946); and The Eight, a group of influential painters. Artists explored topics such as the landscape, poverty and social injustice. Despite initial resistance by the public, the new art movements soon established a unique American identity.

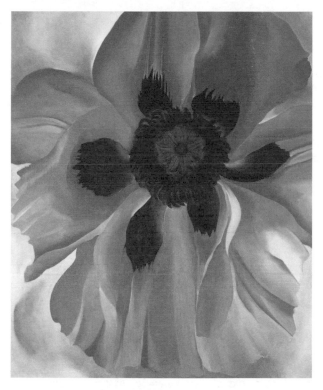

O'Keeffe, *Red Poppy, No. VI*, 1928

Brancusi

With his cutting-edge, sleek and simplified works, Constantin Brancusi (1876–1957) introduced abstraction and Primitivism to three-dimensional art. His originality made him internationally renowned, and he was acknowledged as one of the most influential modern sculptors. Growing up in a Romanian village, he tended the land and learned the traditional folk crafts of wood- and stone-carving. But after studying sculpture in Bucharest, Munich and the École des Beaux-Arts in Paris, he saw a Fauvist exhibition, and realized that artists no longer had to try to emulate the world as it appeared.

An admirer of Gauguin's primitive-style wood carvings, he studied with Rodin, but left after two months, claiming that 'nothing can grow under the shadow of a great tree'. After working with Modigliani, from 1907 he began blending all he had learned in a quest to portray spiritual truths. He emphasized pure lines and balance with natural themes, and reduced his elements to create abstracted, serene ovoid forms with curved, smooth contours.

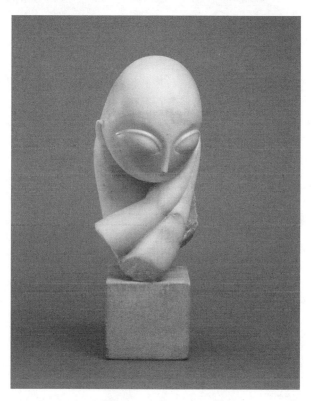

Brancusi, *Mademoiselle Pogany [I]*, 1912

Dada

A reaction to the horrors of the First World War, Dada was an anarchic artistic and literary movement that began in 1916 in neutral Zurich, Switzerland, where many artists and poets lived. Described by its perpetrators as 'anti-art', Dada was influenced by ideas from several other avant-garde movements. It began when artists and writers met at the Cabaret Voltaire, a nightclub owned by writer Hugo Ball (1886–1927) in Zurich. The name Dada was chosen by the poet Tristan Tzara (1886–1930) when he was looking for an illogical word in a dictionary. Diverse and irreverent, Dadaists protested against the brutality of war and the bourgeois society they believed had allowed such atrocities to happen. There was no coherent style, but the art, poetry and performances produced were often satirical and nonsensical. Dada spread to various cities around the world. Its founders included Ball, Tzara and the artists Jean (Hans) Arp (1886–1966), Marcel Duchamp, Francis Picabia (1879–1953), Kurt Schwitters (1887–1948) and, in Germany, Hannah Höch (1889–1978) and Max Ernst.

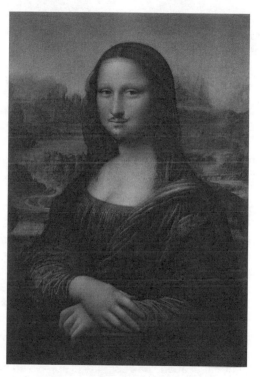

Duchamp, *L.H.O.O.Q. (Mona Lisa with Moustache)*, 1930

Duchamp

In his lifetime, French-born artist Marcel Duchamp (1887–1968) produced relatively few works. But, along with Picasso and Matisse, he helped to define some of the most revolutionary artistic developments during the 20th century and became one of its most influential artists.

Although inspired at first by Matisse and the Fauves, by the First World War, he had rejected the work of many of his contemporaries. His *Nude Descending a Staircase, No.2* created a sensation at the 1913 Armory Show in New York, and the following year he began creating 'readymades' – ordinary objects that he occasionally altered and presented as works of art. In 1917, at the Society of Independent Artists in New York, he exhibited *Fountain*, an upside-down urinal, signed 'R. Mutt'. The controversial work raised questions about how much involvement an artist should have in actual making of art, what constitutes art, and its nature and status. Duchamp argued that using prefabricated objects freed him from the 'trap' of developing a particular style or taste.

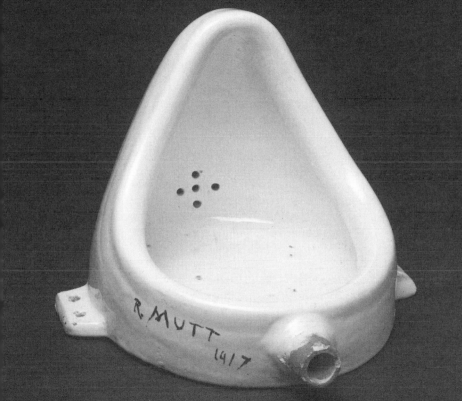

Duchamp, *Fountain (replica),* 1917 original

Metaphysical painting

Reacting against Cubism and Futurism, Metaphysical painting was founded in Italy in 1917 by Giorgio de Chirico (1888–1978), his brother, Alberto Savinio (1891–1952) and ex-Futurist Carlo Carrà (1881–1966). De Chirico began the style c.1911, painting illogical, dreamlike images with sharp contrasts of light and shadow, often with a vaguely threatening, mysterious quality, and usually using dramatic one-point perspective. His ideas arose from his reading of the German philosophers Nietzsche, Schopenhauer and Weininger. The group was later joined by Giorgio Morandi (1890–1964).

Poet Guillaume Apollinaire gave the movement its name when he called de Chirico's painting 'metaphysical', from the Greek for 'beyond real things'. Carrà met de Chirico for the first time in February 1917, and that year, he and de Chirico worked closely together for some months, but in 1919, Carrà published a book, *Pittura Metafisica*, that minimized de Chirico's importance and created great animosity between them.

Chirico, *The Song of Love*, 1914

Surrealism

From 1924 in Paris, poet André Breton (1896–1966) and a small group of writers and artists decided that real truths and feelings could be uncovered through dreams and the subconscious mind, rather than by logical thinking and planning. Influenced by Sigmund Freud (1856–1939), particularly his 1900 book, *The Interpretation of Dreams*, Surrealist writers and artists believed that the conscious mind repressed the imagination.

In 1924, Breton wrote and published the *Surrealist Manifesto*, proposing that artists and writers should access their unconscious to unleash their imaginations. Artists experimented with methods and ideas to release their underlying feelings and thoughts. Max Ernst (1891–1976) for instance, used mechanical techniques to stimulate his imagination, including frottage and collage, Salvador Dalí and René Magritte painted realistic, dreamlike imagery, and artists such as Miró and André Masson (1896–1987) used automatism to express their unconscious thoughts.

Ernst, *Pleiades,* 1921

Automatism

Freud, the founder of psychoanalysis, explored the unconscious minds of his patients using automatism, a form of free association that allowed the unconscious mind to 'speak'. Breton and others in his circle used the same technique in writing; jotting down whatever sprang into their minds without consciously thinking about it. Max Ernst's Surrealist collages were a form of visual automatism, in which he put together images cut from magazines, catalogues, books and other sources, to create unexpected images. André Masson, meanwhile, made automatic drawings in which he did not think about his marks, but simply allowed them to occur led by his unconscious mind.

Painter Joan Miró often starved himself in order to induce hallucinations as he worked: 'In 1925, I was drawing almost entirely from hallucinations. Hunger was a great source of these.' The resulting new language of art was later explored by the Abstract Expressionists in Action Paintings from the mid-1940s, and later became an important element in Art Informel and Tachism.

Arp, *Untitled*, c.1950

Dalí and Magritte

Technically accomplished, prolific and a relentless self-promoter, Spanish artist Salvador Dalí (1904–89) was one of the best-known Surrealists, although he belonged to the group for just a short time. His eccentric personality augmented his impressive technical skill. Interested in classical art, he explored a range of media including painting, sculpture, film, photography and theatre design. He joined the Surrealists in 1929, and used his vivid imagination, illusionistic ideas and incredibly lifelike technique to produce highly detailed, fantastic and often macabre paintings that he described as 'hand-painted dream photographs'.

Belgian René Magritte (1898–1967) became known for witty and thought-provoking images that challenge preconceptions. His paintings of everyday objects in unnatural proportions, and strange locations and juxtapositions, force viewers to consider what the images truly represent. Using thick, smooth paint and clean lines, his images present sometimes shocking paradoxes that focus on the mysteries of existence and absurd ambiguities.

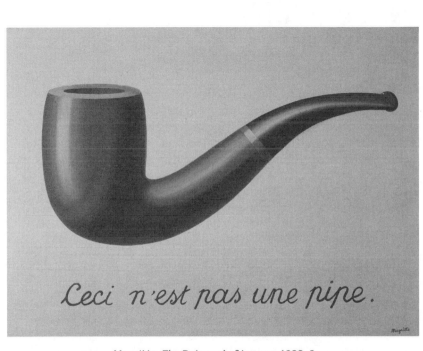

Magritte, *The Betrayal of Images*, 1928-9

Neue Sachlichkeit (New Objectivity)

Taking its name from an exhibition held in Mannheim in 1923, Neue Sachlichkeit was a German movement whose artists rejected contemporary avant-garde art and expressed its disillusionment with the world around them. Seeking to depict reality as they saw it, they made social commentaries in savage visual satires on the human condition. The two key artists were Otto Dix (1891–1969) and George Grosz (1893–1959): they graphically depicted corruption and hedonism of the ineffectual Weimar Republic that governed between the country's defeat in the First World War and the rise of the Nazi Party in 1933.

Two major trends emerged within the movement. The Verists, including Dix, Grosz and Max mnddjdjn (1884–1950), attacked the evils of society and depicted the devastating effects of the war. The Magic Realists, including Heinrich Maria Davringhausen (1894–1970) and Georg Schrimpf (1889–1938), aimed to counter the aggression and subjectivity of Expressionism by painting magical or unreal elements in otherwise ordinary environments.

Grosz, *Twilight*, 1922

The Bauhaus

Architect Walter Gropius (1883–1969) founded the Bauhaus School of Art, Craft and Design in Weimar, Germany in 1919. Aiming to unify art, craft and technology, Gropius developed a curriculum that would produce artisans and designers able to create useful and beautiful objects. It began with a preliminary course teaching the basic elements and principles of design and colour theory, and practical work. Students then specialized in disciplines of their choice. The system became adopted by art and design schools across the world.

Teachers included Gropius, Johannes Itten (1888–1967), Oskar Schlemmer (1888-1943), Kandinsky, van Doesburg, El Lissitzky and László Moholy-Nagy (1895–1946). In 1923, the Bauhaus adopted the slogan 'Art into Industry', and in 1925, moved to Dessau, where Gropius designed a building with many features that later became characteristic of Modernist architecture. In 1928, Hannes Meyer (1889–1954) became director, and from 1930 to 1933, Ludwig Mies van der Rohe (1886–1969) led the school.

Schlemmer,
Bauhaus Stairway,
1932

American Realism, Precisionism, Regionalism

American Realism (or Social Realism) was one of several strands to American Modernism that develped in the early 20th century. It depicted contemporary society, capturing feelings and textures, sometimes with underlying hints of the psychological tensions of modern life, as in the work of Edward Hopper and the Ashcan School. Precisionism, meanwhile, emerged after the First World War and reached its peak in the 1920s and early 1930s. The first indigenous modern art movement, it was a celebration of new American landscapes of skyscrapers, bridges and factories. Artists included Charles Sheeler (1883–1965) who produced meticulously detailed paintings and sharply focused photographs of factories and public buildings. Regionalists, in contrast, celebrated the quiet, hard-working lives of Americans living in small towns and the countryside, away from city life. They included Grant Wood (1892–1942) and Thomas Hart Benton (1889–1975). During the Great Depression of the 1930s, Regionalism was widely appreciated for its reassuring images of indomitable Americans.

Hopper, *Automat*, 1927

Mexican art

A rich blend of many sources, Mexican art reflects a complex history. Centuries of colonial occupation and social protest evolved into civil war and revolution in the early 20th century. Following the revolution, the government commissioned artists to educate ordinary people about Mexican history. The Mexican Muralists, who included Diego Rivera (1886–1957), José Clemente Orozco (1883–1949) and David Alfaro Siqueiros (1896–1974), produced large, colourful murals on public buildings, mixing images from the country's troubled past, folk art and the art of the ancient Maya and Aztecs. The Muralists, who became known as *Los Tres Grandes* (The Three Great Ones), hoped their paintings would help to bring Mexican civilians together. Rivera painted colourful, idealistic images, Orozco produced darker, more pessimistic work and Siqueiros created satirical images using various materials. Rivera's wife, Frida Kahlo (1907–54), suffered lifelong health problems and expressed both her personal problems and her nationalistic feelings through autobiographical paintings, with specific Mexican references.

Rivera, *The Flowered Canoe*, 1931

Socialist Realism

Socialist Realism (not to be confused with Social Realism) was conceived as 'the representation of the proletarian revolution' and produced as communist propaganda. It was a type of realistic art established by Joseph Stalin (1878–1953) in the Soviet Union, with style and content intended to further the goals of socialism and communism, and its influence spread to other socialist countries. By 1934, all independent or avant-garde art groups in the USSR were abolished, and only official, Socialist Realism was allowed, created to be understood by the masses of illiterate Russians and to portray their courage and struggles against adversity, inciting hope, patriotism, revolutionary action and productivity.

In its attempt to build socialism and a classless society, the art celebrates the workers, using naturalistic idealization to portray ordinary Russians as brave, resolute, young, healthy and reliable. Although intended to be lifelike, the imagery was not credible, and the style came to an end with the fall of the Soviet Union in 1991.

Statues in Budapest
Szoborpark, 1950s

Harlem Renaissance

A cultural explosion took place during the 1920s and 1930s among black Americans living in America. Inspired by their African heritage, they explored music, dance, film, painting, theatre and cabaret, incorporating jazz and blues music, and colourful, expressive painting.

Even after the American Civil War had ended in 1865, southern states did not give liberated black slaves the vote and most amenities were segregated by race. As industrialization created job opportunities in the north, some 2 million African Americans migrated from 1910 to 1930, settling in cities such as Chicago, Philadelphia, Cleveland and New York. After years of oppression, they began conveying a new-found optimism in many ways. The Harlem district of New York City in particular attracted a number of talented individuals, and became symbolic capital of a wider art movement whose members included Aaron Douglas (1898–1979), William H. Johnson (1901–70), Lois Mailou Jones (1905–98), Sargent Claude Johnson (1888–1967) and Charles Alston (1907–77).

Jacob Lawrence, *The Migration Series, Panel No. 1*, 1940–41

St Ives and the Newlyn School

The unique light, distinctive landscape and wild seas of Cornwall in southwest England have always been a magnet for artists. In the late 19th century, a group of painters settled in the fishing villages of Newlyn and St Ives, and began depicting local scenes of rural life, capturing the light, rolling land, rugged coast and dramatic sea. Led by Stanhope Forbes (1857–1947) and Frank Bramley (1857–1915), they became known as the Newlyn School.

St Ives attracted artists who were inspired by the shallow crescent of its bay, and the clear natural light. In 1920, Bernard Leach (1887–1979) and Shoji Hamada (1894–1978) set up a pottery, and during the 1930s, Ben Nicholson (1894–1982), Barbara Hepworth (1903–79) and Christopher Wood (1901–30) established an artists' colony. For a short time they were joined by the Russian Constructivist Naum Gabo. From c.1950, younger artists also took inspiration from the locality. They included Wilhelmina Barns-Graham (1912–2004), Terry Frost (1915–2003), Roger Hilton (1911–75), Patrick Heron (1920–99) and Peter Lanyon (1918–64).

Walter Langley, *A Newlyn Street*, c.1885

Art Brut and CoBrA

Invented by the French artist Jean Dubuffet (1901–85), Art Brut (Raw or Crude Art) describes a type of graffiti or naïve art created from 1945. Inspired by the art of the insane, prisoners, children and primitive artists, Dubuffet believed that artists were suppressed by academic training, and incorporated unrestrained, unrefined qualities into his own art. He covered canvases with glue, sand and resin, painted over them and scratched the surface with arbitrary symbols.

In 1948, artists from Copenhagen (Co), Brussels (Br) and Amsterdam (A) formed CoBrA, an avant-garde movement that opposed Surrealism and instead used lines, colours and forms freely. Members including Karel Appel (1921–2006), Corneille (1922–2010), Christian Dotremont (1922–79), Asger Jorn (1914–73) and Joseph Noiret (1927–2012) signed a manifesto, *La Cause Était Entendue* ('The Case Was Settled'). Although a group, each artist experimented and worked spontaneously, drawing inspiration from Klee, Miró, children's drawings and primitive art.

Dubuffet, *Bedouin, raised arms*, 1948

Abstract Expressionism

As Europe struggled to recover in the aftermath of the Second World War, America moved into a position of political, economic and cultural power. The Abstract Expressionists were a small group of loosely associated artists who had worked in diverse styles before the war, but by the 1940s began working in radical new directions, reflecting the mood of the moment. As the first US art movement to have an international impact, they ultimately led to New York supplanting Paris as the centre of the art world. Lacking a precise definition, Abstract Expressionism was inspired by various ideas, particularly Surrealism, many of whose followers had fled to America during the war. Most Abstract Expressionists built on the ideas of automatism, producing paintings generated by their innermost feelings, using spontaneous gestures and uninhibited action. This became known as Action Painting, or Gestural Abstraction. The artists dripped, poured and threw paint over their canvases as they expressed their inner emotions. Those involved included Jackson Pollock (1912–56), Willem de Kooning (1904–97), Arshile Gorky (1904–48) and Franz Kline (1910–62).

Pollock, *Watery Paths*, 1947

Colour Field

The term 'Colour Field' was originally used c.1950 to describe the work of painters such as Mark Rothko (1903–70), Barnett Newman (1905–70), Robert Motherwell (1915–91), Ad Reinhardt (1913–67) and Clyfford Still (1904–80). They covered large canvases with single or limited colour areas whose edges dissolve or merge together. There are no links to the outside world, no recognizable elements and no obvious emotional input by the artists themselves. Yet they were produced to elicit emotional or contemplative reactions in viewers. The lack of frames also blurs distinctions with the wider world, and most exude a tranquillity intended to inspire contemplation.

'Post-Painterly Abstraction' is a broad term used to encompass a variety of styles developed in reaction to the painterly, gestural approach of some Abstract Expressionists. Writer Clement Greenberg (1909–94) first coined the phrase to describe various developments of Abstract Expressionism, including particularly Colour Field and Hard Edge painting.

Rothko, *Untitled*, 1966–7

Hard Edge painting

An aspect of Colour Field developed during the 1960s that became known as Hard Edge painting. The artists involved applied intense colours smoothly, emphasizing the flatness of their surfaces, but instead of blurring their coloured edges, they created sharply defined outlines, geometric contours and clean, firm lines, filled with bold units of bright colour. Influenced by Synthetic Cubism, Neo-Plasticism, Suprematism and the Bauhaus, Hard Edge artists rejected the gestural, unstructured and spontaneous approach of Abstract Expressionism.

Recognized for its economy of form, bright colours and smooth surface planes, Hard Edge painting was initially applied to the work of four artists from California: Karl Benjamin (1925–2012), John McLaughlin (1898–1976), Frederick Hammersley (1919–2009) and Lorser Feitelson (1898–1978). Although their styles varied, they were united by their use of clean lines, intense colour and smooth surfaces. Applying their paints carefully and thoughtfully, they made sure that no notion of drama or spirituality was involved.

Kenneth Noland, *Breath*, 1959

Assemblage

The word 'assemblage' was first applied by Dubuffet in the early 1950s to a series of collages of butterfly wings that he called *Assemblages d'Empreintes*. However, the earliest examples of this kind of artwork are probably Synthetic Cubist works by Picasso and Braque, or Duchamp's readymades. Since then, assemblages, comprising usually banal, natural or manufactured materials, objects or fragments of things that were not originally intended as art materials, have become a fairly regular form of art. Some artists have created these three-dimensional collages almost exclusively, others as a small part of an overall body of work. A 1961 New York exhibition 'The Art of Assemblage' showcased the work of nearly 140 artists, including Braque, Dubuffet, Duchamp, Picasso, Schwitters, Man Ray (1890–1976), Joseph Cornell (1903–72), Robert Rauschenberg (1925–2008) and George Herms (b.1935). The diversity of materials, styles and ideas on display was vast. Cornell, for instance, became known for his boxed assemblages created from found objects that combine elements of Constructivism with Surrealistic fantasies.

Cornell, *Penny Arcade*, c.1962

Minimalism

In 1965, British philosopher Richard Wollheim (1923–2003) wrote an essay called 'Minimal Art', referring to Colour Field painting and Dada. The term was not new – it had already been used in 1929 by the Ukrainian Futurist David Burliuk (1882–1967), but it gained momentum in the 1960s, specifically describing a style of art characterized by detached restraint, plain geometric compositions and structures, and industrially processed materials, such as house bricks or fluorescent lights.

Frank Stella (b.1936) became particularly influential after exhibiting his series of Black Paintings, consisting of black stripes with no hidden meanings in 1959. Donald Judd (1928–94) rejected the name 'Minimalist', but explained the concept as having a compositional 'wholeness'. Other Minimalists included Robert Morris (b.1931), Yves Klein (1928–62), Robert Rauschenberg, Ad Reinhardt and Carl Andre (b.1935). Minimalists never worked or exhibited as a group, but common features included large scale, simplicity and modular or serial compositions.

Judd, *Untitled*, 1984

Pop art

After the austerity of the Second World War, mass production, mass media and consumerism proliferated in America and Europe. Beginning as a revolt against attitudes towards art, Pop art emerged in London and New York in the mid-1950s and 60s. Many Pop artists perceived Abstract Expressionism as being self-indulgent, and most were critical of capitalism and art snobbery.

Pop artists used everyday, mass media sources such as Hollywood, advertising, packaging, pop music and comics, declaring that art can borrow from any source, that it's art if the artist says it is, that art is for everyone and has no boundaries. Pop artists also explored several non-traditional, commercial methods of production. A shared notion was that the art should present ideas impersonally and objectively, with no emphasis on feelings or symbolism. Pop artists include Andy Warhol, Roy Lichtenstein, Richard Hamilton (1922–2011), Peter Blake (b.1932), Jasper Johns (b.1930), David Hockney, Claes Oldenburg (b.1929), Patrick Caulfield (1936–2005), and Eduardo Paolozzi (1924–2005).

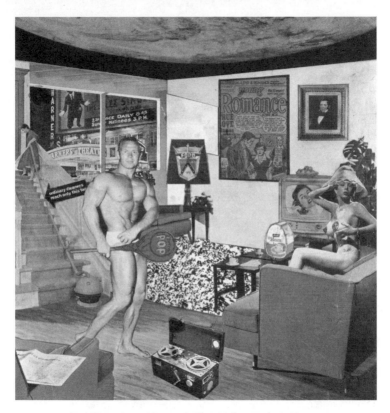

Hamilton, *Just What is it That Makes Today's Homes So Different, So Appealing?*, 1956

Warhol , Lichtenstein and Hockney

Recognized as much for his flamboyant lifestyle as for his art, Andy Warhol (1928–87) started out as a successful commercial artist. He worked in many media, including drawing, painting, printmaking, photography, silk screen, sculpture, film and music. Exploring relationships between artistic expression, celebrity culture and advertisement, his bold, flat depictions of subjects ranged from Campbell's soup cans to film stars, both celebrating and condemning American mass culture. He broke new ground in deliberately mis-registering images, using assistants to produce much of his work, and presenting everyday items as art.

Roy Lichtenstein (1923–97), another leading American artist, used innovative methods of mixing mechanical reproduction with hand drawing to create large, dynamic, comic-style images that have become synonymous with Pop Art. Versatile British artist David Hockney (b.1937), meanwhile, used his draughtsmanship and sense of colour to incorporate the essentials in contemporary images that are usually brilliantly coloured and bathed in light.

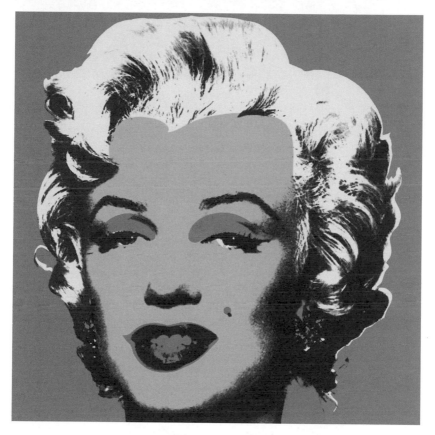

Warhol, *Marilyn*, 1967

Op art

Beginning in the mid-1950s, Op art saw the possibilities of optical illusion exploited by artists who were inspired by Suprematism, Constructivism, Neo-Plasticism, the Bauhaus and Hard Edge painting. They created abstract, geometric designs and patterns that contrast strongly with their backgrounds in order to generate sensations of movement or vibration in viewers' eyes. Also sometimes called Retinal art, the style was described as Op art (for Optical art) in *Time* magazine in 1964.

Both Op and Kinetic art styles were launched at 'Le Mouvement', a 1955 exhibition in Paris. Ten years later 'The Responsive Eye', another exhibition at the Museum of Modern Art in New York, showed similar work. It included art by Richard Anuszkiewicz (b.1930), Victor Vasarely (1906–97) and Bridget Riley (b.1931), and was enormously popular with the public. Critics denounced it as portraying nothing more than tricks to fool the eye, but Op art caught the collective imagination and led to a craze for similar designs in fashion and the media.

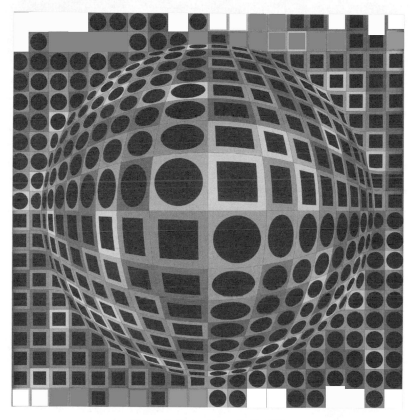

Vasarely, *Vega–Gyongiy–2*, 1971

Kinetic art

Between 1913 and 1920, artists including Gabo, Duchamp and Tatlin began to emphasize mechanical movement in some of their work. Duchamp's *Bicycle Wheel* of 1913, the first of his readymades, comprises a stool with a freely spinning bicycle wheel fixed into it. In 1920, Alexander Rodchenko also created moving art, with hanging mobiles of geometric shapes – Constructivist objects that he called *spatial constructions*. Also in 1920, the word 'kinetic' was first used to describe moving art by Gabo and his sculptor brother Antoine Pevsner (1886–1962) in their *Realistic Manifesto*. The idea flourished into a lively trend with an exhibition, 'Le Mouvement', in Paris in 1955.

Kinetic artists were fascinated by the possibilities of movement in art, and its potential to create new, interactive experiences among viewers. Jean Tinguely (1925–91) created large-scale works welded out of scrap metal, while Alexander Calder (1898–1976) built mobiles with delicately balanced or suspended components that move in response to motor power or air currents.

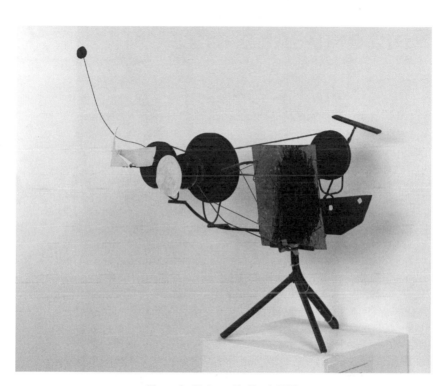

Tinguely, *Metamatic No. 1,* 1959

Performance art

Performance art emerged in the 1950s, inspired by diverse ideas including Dada and the Cabaret Voltaire, Abstract Expressionism, Futurist theatrical events, Pop art and the horrors of two world wars. Many Performance artists were also influenced by a 1950 series of photographs by Hans Namuth (1915–90) that showed Jackson Pollock creating Action Paintings.

In the late 1950s, Allan Kaprow (1927–2006) organized interactive events or 'Happenings' in New York. Soon, other artists were using their bodies to express themselves, in dance, mime, singing or acting, often in unexpected locations. Audiences were generally expected to participate, or question aspects of society. Known as Actionism in Austria and Germany, it became quite a phenomenon in the 1960s and 1970s, expressed by artists including Vito Acconci (b.1940), Bruce Nauman (b.1941) and Joseph Beuys (1921–86). Beuys's 'Actions' involved complex allegories of social and political issues. The main purpose of Performance art has nearly always been to challenge the conventions of more traditional art forms.

Beuys with his installation *'The Pack'*, 1969

Aboriginal Dreamtime

Australian Aboriginal art has always been closely linked to spiritual beliefs and mythology. The Dreamtime describes myths that are the basis of Aboriginal society and have lasted for thousands of years. The Aborigines believe the land they occupied was once completely empty until, during the Dreamtime, the land and sky were formed by supernatural, mysterious beings who rose from the earth and took human, animal or plant form. These Spirit ancestors continue to wander the earth, leaving sacred tracks.

Creatures of the Dreamtime include the Rainbow Serpent, All-father and All-mother figures. The arrival of Europeans saw the Aborigines dispersed and assimilated, but some traditions were retained, and Dreamtime forms the basis of Aboriginal art. Many artists now paint in acrylic on board, but their abstract work retains older elements – intense colours and symbolic motifs, wavy lines, dots and concentric circles. Prominent artists include Emily Kngwarreye (c.1910–96), Ginger Munduwalawala (c.1936–2002), Clifford Tjapaltjarri (c.1932–2002) and Rover Joolama (c.1926–98).

Clifford Possum Tjapaltjarri, *Corkwood Dreaming*, 1992

Arte Povera

In 1967, Italian art critic and curator Germano Celant (b.1940) described the work of several young Italian artists in Genoa, Milan, Rome and Turin as 'Arte Povera' (Poor or Impoverished Art). The artists were all working in new ways, breaking with the past, and exploring unconventional processes and 'everyday' materials such as earth, rocks, rags, rope and twigs. By using these 'poor' materials in paintings, sculpture, installations, photographs and performances, artists focused on relationships between art and life. They were also reacting against the abstract painting that dominated art at the time, and which they thought was too narrowly concerned with emotion and individual expression, and too confined by the traditions of painting. Arte Povera became the most significant and influential avant-garde movement to emerge in Europe in the 1960s. Prominent artists included Giovanni Anselmo (b.1934), Alighiero Boetti (1940–94), Luciano Fabro (1936–2007), Jannis Kounellis (b.1936), Mario Merz (1925–2003), Marisa Merz (b.1926), Giulio Paolini (b.1940), Giuseppe Penone (b.1947) and Michelangelo Pistoletto (b.1933).

Penone, Installation
in the gardens
of the Palace of
Venaria, 1997

Land and Environmental art

The scope of art expanded in the late 1960s as some American and European artists began to make vast sculptures out of natural materials, often in the landscape. This became known as Land art, Environmental art or Earthworks. Seeking to move away from what they saw as the commercialism of the art world, Land art developed as part of the Conceptual art movement of the 1960s and 1970s, and had no single style or approach. Some artists sculpt into the earth, some use natural, local materials to create installations on the spot, some take natural materials back to galleries and build sculptures or installations there. Some make marks using parts of the environment, take photographs as a record and leave the land to return to its former state.

Most Land art is transitory, and most Land artists are highly respectful of the environment. Among the most prominent are Robert Smithson (1938–73), Richard Long (b.1945), Andy Goldsworthy (b.1956), Nancy Holt (b.1938), and Christo (b.1935) and Jeanne-Claude (1935–2009).

Graffiti art

By creating art on the streets, artists can communicate directly with the public away from museums and galleries. The word 'graffiti' comes from the Italian *graffiato* meaning 'scratched', and the earliest examples were carved on walls with sharp objects, such as in the Roman and Pompeian catacombs. The Mayan site of Tikal in Guatemala also contains ancient examples.

Graffiti art flourished in 1970s New York, notably with artists such as Jean-Michel Basquiat (1960–88) and Keith Haring (1958–90). Basquiat achieved notoriety as part of SAMO, an informal graffiti group based in Manhattan's Lower East Side, while Haring, inspired by Dubuffet and Warhol, also became involved with the New York street culture of the 1980s. Lee Quiñones (b.1960) was part of a Subway graffiti movement entrenched in popular culture, frequently using political messages. The elusive British graffiti artist Banksy creates realistic satirical images of political and social commentary on pavements, walls and bridges in cities around the world.

Basquiat, *Untitled*, 1981

Conceptual art

Arising from Duchamp's flouting of the rules of art, the term Conceptual art was first used by American artist Sol Lewitt (1928–2007) in a 1967 article in *Artforum* magazine. It generally describes artworks in which concepts are more important than traditional aesthetic and material concerns.

Conceptualism is an umbrella term that covers several types of art, including Performance, installations, Video art, Land art, Arte Povera and others. A reaction against the emotionalism of Abstract Expressionism, it was detached and analytical, questioning assumptions about the role of art and museums, and the function of artists. Many Conceptual artists used writing rather than visual creations, while others used photography, film, video and other non-traditional materials to create their broad and disparate ideas. Those involved included: Joseph Kosuth (b.1945), Piero Manzoni (1933–63), Rauschenberg, Ad Reinhardt, John Baldessari (b.1931), and Gilbert & George, or Gilbert Prousch (b.1943) and George Passmore (b.1942).

Language (læ·ŋgwĕdʒ), *sb*. ME. [a. F.
langage :—pop.L. type *linguaticum*, f. *lingua*
tongue, language (F. *langue*; see LANGUE).
The *u* is after F. *langue*.] **1.** The whole body
of words and of methods of combining them
used by a nation, people, or race; a 'tongue'.
b. *transf.* Method of expression otherwise than
by words 1606. **2.** *gen.* Words and the
methods of combining them for the expression
of thought 1599. **b.** Faculty of speech; ability
to speak a foreign tongue. Now *rare*. 1526.
3. Manner or style of expression ME.

Kosuth, *Titled (Art as Idea as Idea)*, 1967

Photorealism and Hyperrealism

Evolving from Pop art and opposed to both Minimalism and Abstract Expressionism, Photorealism revived the highly finished surfaces of 17th-century Dutch painting. From the late 1960s, skilful artists including Robert Bechtle (b.1932), Charles Bell (1935–95), Chuck Close (b.1940), Robert Cottingham (b.1935), Richard Estes (b.1932) and Audrey Flack (b.1931) mimicked photographic images, usually on a large scale, including areas of blurred focus and frozen motion. Hyperrealism developed about 20 years later, and as the name suggests, goes beyond the simulation of photography. Meticulously detailed, Hyperrealist paintings and sculptures create illusions of reality. Textures, surfaces, lighting effects and shadows appear clearer and more distinct than the reference photographs, as artists emphasize details. Unlike the literal detachment of Photorealism, Hyperrealism often incorporates emotional, social, cultural and political elements. High-profile Hyperrealists include Duane Hanson (1925–96), Ron Mueck (b.1958), Charles Bell and Denis Peterson (b.1944).

Domenico Gnoli, *Shoe*, 1969

Pluralism and Postmodernism

From around 1970, art movements emerged and dissolved with increasing speed. Artists employed a broader range of materials, approaches and processes than ever before, including video, performance, computers and the internet, as well as traditional materials. Incorporating a variety of styles, ideas and cultural trends, with no dominant culture or country leading the way, Pluralism seemed to be the most appropriate way of describing it all.

Postmodernism is another umbrella term for art movements that sought to challenge aspects of Modernism. It is often seen as starting with Pop art's elimination of distinctions between high and mass culture, and its refusal to accept the authority of any one style or definition of what art should be. Postmodern art is often quirky, absurd, irreverent or meaningless. Postmodernists often work with new technologies, including television, video, smartphones, computers and the internet, sourcing, manipulating and processing imagery.

Centre Georges Pompidou, Paris, 1972–77

Feminist art

In the late 1960s, Feminist art emerged in the USA and Britain as part of the general feminist movement. It was further fuelled in 1971, when art historian Linda Nochlin (b.1931) published her essay 'Why Have There Been No Great Women Artists?' Investigating the factors that had prevented women artists from achieving equal status to their male counterparts, Nochlin inspired many more females who aimed to counter centuries of male-dominated art.

That same year, Judy Chicago (b.1939) and Miriam Schapiro (b.1923) set up the Feminist Art programme at the California Institute of the Arts, while in England, art critics Rozsika Parker (1945–2010) and Griselda Pollock (b.1949) founded the Women's Art History Collective in 1973. With no unifying style, Feminist artists combined aspects from various art movements and media, such as performance and video. Expressing messages about women's unique experience, they include Chicago, Schapiro, Barbara Kruger (b.1945), Louise Bourgeois (1911–2010), Cindy Sherman (b.1954), Tracey Emin (b.1963) and the Guerrilla Girls.

Tracey Emin, *My Bed*, 1998

School of London

In 1976, at the height of Minimalism and Conceptualism, the London-based American painter R.B. Kitaj (1932–2007) organized an exhibition at the Hayward Gallery titled 'The Human Clay'. Consisting exclusively of then-unfashionable figurative drawing and painting, the exhibition proved highly controversial. In the catalogue, Kitaj used the term 'School of London' to describe the exhibiting artists, who also included Michael Andrews (1928–95), Frank Auerbach (b.1931), Francis Bacon (1909–92), Euan Uglow (1932–2000), Lucian Freud (1922–2011), Hockney, Howard Hodgkin (b.1932) and Leon Kossoff (b.1926). Rather than a coherent style or approach, the 'School' was held together by friendship and a strong belief in figurative painting, despite contemporary fashion.

Each artist expressed his ideas in intensely personal work – Bacon, for instance, used distortion to express emotions such as desolation, cruelty and fear, while Freud's later work built up impressions of flesh with thick, granular paint. Despite the initial controversy, the School of London inspired many younger artists.

Bacon, *Self-Portrait*, 1976

Neo-Expressionism

Renowned for their rather brash figurative paintings, often created with unusual techniques, the Neo-Expressionists emerged in the 1970s in America, West Germany and Italy. Initiated by Georg Baselitz (b.1938), the movement was a revival of Expressionism that rejected the intellectualizing movements of Minimalism and Conceptualism. By the 1980s, it had become the main art movement in the West, generated by new and aggressive forms of promotion and marketing. Neo-Expressionists painted large-scale works in a crude, textural and emotive manner, inspired by Expressionism, Abstract Expressionism and Picasso's late works. The paintings are diverse in appearance, but share common traits, including a rejection of traditional composition and order; tense emotional interpretations of contemporary urban life; vivid, discordant colours; and a primitive style that suggests a sense of inner turmoil. Leadng Neo-Expressionists included Americans Julian Schnabel (b.1951) and David Salle (b.1952), Italians Sandro Chia (b.1946) and Francesco Clemente (b.1952), and Germans Baselitz and Anselm Kiefer (b.1945).

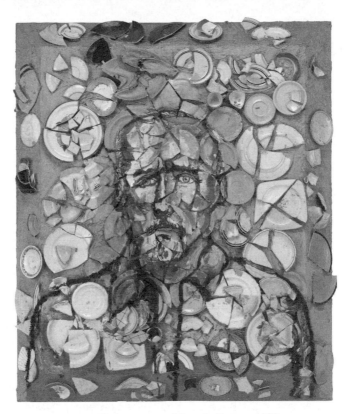

Schnabel, *Portrait of Dennis Hopper*, 1999

Neo-Geo

Short for 'Neo-Geometric Conceptualism', Neo-Geo has also been called Neo-Conceptualism, Neo-Futurism, Neo-Op, Neo-Pop, New Abstraction, Neo-Minimalism, Simulationism and Smart Art. Developed in the 1980s, it describes the work of a loose group of artists who criticized mechanization and commercialism. Yet paradoxically, its popularity was largely fuelled by aggressive marketing. Artists linked to the movement include Ashley Bickerton (b.1959), Peter Halley (b.1953), Lorenzo Belenguer (b.1965), Jeff Koons (b.1955), Meyer Vaisman (b.1960), David Burdeny (b.1968), Haim Steinbach (b.1944), Peter Schuyff (b.1958) and Marjan Eggermont (b.1966). Styles varied, but all these artists began from similar standpoints and all worked figuratively, drawing on earlier movements including Minimalism, Abstract Expressionism, Pop and Op art. They developed a new form of geometric painting and three-dimensional work, some bright and colourful, some austere, and often featuring items such as microchips and circuit boards. The steel sculptures of Richard Serra (b.1939) have been described as 'austere Neo-Geo'.

Javier Mariscal, *La Gamba*, 1989

Installations

The term 'installation' describes a mixed-media construction or assemblage usually created for a specific place and for a temporary period – they have become an increasingly popular form of art since artists used more diverse media in the late 20th century, allowing the creation of unique environments that can occupy an entire room or gallery, transforming visitors' perceptions of the space. Constructed in galleries, museums or public environments, they usually consist of numerous elements, and are a logical progression from styles such as Colour Field painting, which deliberately relinquished frames in order to make the work seem part of the wider world.

American performance artist Allan Kaprow created some of the first installations from c.1957. His concept of 'environments', became a significant element in modern art, treated uniquely by different artists. James Turrell (b.1943), for instance, creates installations focusing on light and space, while Anish Kapoor (b.1954), explores distortions of space in installations and permanent sculpture.

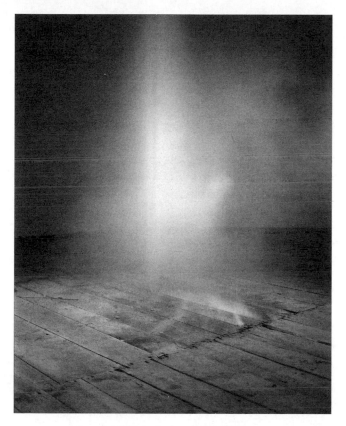

Anish Kapoor, *Ascension*, 2003

The YBAs

In 1997, a radical exhibition called 'Sensation' was held at London's Royal Academy. It included the work of artists including Damien Hirst (b.1965), Sarah Lucas (b.1962), Cornelia Parker (b.1956), Gary Hume (b.1962), Rachel Whiteread (b.1963), Marc Quinn (b.1964), Michael Landy (b.1963), Jake and Dinos Chapman (b.1966 and 1962 respectively) and Tracey Emin. Their collective nickname of the YBAs (Young British Artists) was more of a marketing term than an art movement, and deflected their diversity, but most shared an openness towards materials and processes, and many used installations, found objects, shock tactics and entrepreneurial attitudes.

Many of the group first exhibited in a 1988 show organized by Hirst and his contemporaries at Goldsmiths College of Art. Notoriously, the YBAs have preserved dead animals, crushed found objects, exhibited a dirty bed and made sculpture out of food, cigarettes and women's tights. But they have also made extensive use of film, video, photography, drawing, painting and printmaking.

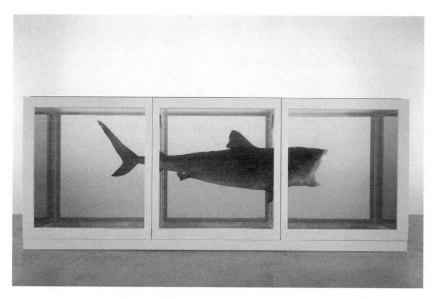

Hirst, *The Physical Impossibility of Death in the Mind of Someone Living*, 1991

Computer and internet art

Since the mid-1960s, many artists have experimented with new technologies such as video, computers and the internet, allowing some to incorporate elements of mass communication and computer-generated imagery in their work. The first exhibitions of computer art were held in 1965 in Stuttgart, New York and Las Vegas, but one of the most influential was hosted by London's Institute of Contemporary Arts (ICA) in 1968: 'Cybernetic Serendipity' showcased work by pioneers of digital media such as Nam June Paik (1932–2006), Frieder Nake (b.1938), Georg Nees (b.1926), A. Michael Noll (b.1939), John Whitney (1917–95) and Charles Csuri (b.1922). The following year, the Computer Arts Society was established in London: computer and video art has since become widespread. Since the mid-1990s, the World Wide Web, invented by British computer scientist Tim Berners-Lee (b.1955) has itself become a forum for art. Rather than confining art to galleries and museums, internet art is interactive and inter-connective, dissolving boundaries between artists and viewers.

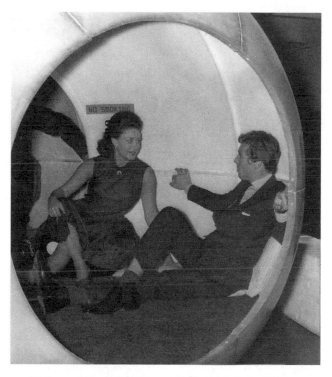

Visitors at the 1968 'Cybernetic Serendipity' exhibition

Glossary

Aerial perspective
Also *atmospheric perspective* –
a method of creating illusions
of depth or recession in which
colours become weaker and
bluer with distance.

Aesthetics
Derived from the Greek
word 'aesthesis' meaning
perception, this describes
what makes something
beautiful or ugly.

Anthropomorphic
Something that is not human
given human aspects or
attributes.

Bodegóns
In Spanish art, a painting set
in a kitchen or tavern, often
including one or more figures.
From the Spansh *bodega*,
meaning 'pantry', 'tavern', or
'wine cellar'.

Bourgeoisie
The middle class of society,
often considered to be led
by materialism and a concern
for respectability and social
advancement.

Collage
A technique in which pieces of
paper, photographs, fabric and

other materials are glued on a support to create pictures or patterns, and also the resulting work of art.

Contrapposto
An Italian term meaning counter-pose, used to describe a figure standing with most weight on one foot, and the shoulders and arms twisting in the opposite direction to the hips and legs.

Foreshortening
Distorted depictions of things to convey dramatic perspective.

Fresco
A mural painting technique using water-based paint. *Buon fresco* is painting on to wet plaster so the paint becomes an integral part of the wall, and *fresco secco* is painting on to dry walls.

Ground
Usually a preliminary coating or priming for a drawing or painting on a support such as canvas or panel.

Hieroglyphics
A form of writing, especially of ancient Egypt, in which pictures and symbols are used to represent objects, ideas, or sounds

Humanism
A form of thought that makes people the first consideration as a basis for philosophical enquiry.

Iconoclasm
The wilful destruction of religious imagery and icons.

Iconography
Types of imagery used by artists to convey particular meanings. For example, in Christian painting, the dove representing the Holy Spirit.

Illusionistic
Artists' attempts to represent the visual world, to create the appearance of three-dimensions on flat, two-dimensional surfaces.

Life drawing
The drawing of live, usually nude, human models – an important part of much formal artistic training.

Linear perspective
Drawing or painting three-dimensional illusions on two-dimensional surfaces, primarily using line. Objects far away become smaller and receding parallel lines appear to converge on the horizon.

Meander
A decorative border made from a continuous geometric line, repeatedly turning back on itself – also called the Greek fret or key pattern.

Motif
A dominant or recurring idea in a work or an artist's oeuvre.

Movable type
A system of printing and typography that uses movable,

reusable components to reproduce symbols.

Narrative
Art that tells a story, either as a moment in a story, or as a sequence of events.

Painterly
The application of paint in a loose, free manner, leaving visible brushstrokes in the finished painting.

Readymades
A term first used by Marcel Duchamp to describe works of art made from previously manufactured objects.

Reliefs
A kind of carving or sculpture raised from a flat background, like a three-dimensional picture. High and low (or bas) relief refers to the depth of protrusion.

Stucco
Fine plaster used for coating wall surfaces or moulding into architectural decorations.

Theosophy
A religious philosophy popular in thr late 19th and early 20th centuries, incorporating aspects of Buddhism and Brahmanism.

Tronies
Types of portraits often involving costume-wearing, used by artists as studies of expression, type, appearance, or characters.

Index

Abstract art 316, 320
Abstract Expressionism 360, 362, 370
Academic art 216
Académie des Beaux-Arts 118, 216
Aesthetic movement 226, 238
African art 288
Akkadian art 12
Altdorfer, Albrecht 110
American Modernism 328, 348
American Realism 348
ancient art 8–20
Angelico, Fra 80, 81
animals 180
Archaic Greece 28, 29, 36
art academies 118, 216
Art Brut 358
Art Nouveau 86, 276
Arte Povera (Poor Art) 382
Arts and Crafts 220, 276, 284
Ashcan School 282, 328, 348
Assemblage 366
Assyrian art 14
Automatism 338, 340, 360
Aztecs 58

Babylonian art 14
Bacon, Francis 396
Banksy 386
Barbizon School 230, 234
Baroque 132, 134, 138, 140, 142, 150, 152

Basquiat, Jean-Michel 386, 387
Bauhaus 346
Bellini, Giovanni 98, 100
Bellows, George 282, 283
Bernini, Gian Lorenzo 138
Beuys, Joseph 378, 379
black-figure pottery 30, 31
Bloomsbury Group 312
Boccioni, Umberton 308, 309
Bosch, Hieronymus 108, 109
Botticelli, Sandro 86, 87
Boucher, François 172, 173
Bouguereau, William-Adolphe 216, 217
Brancusi, Constantin 330, 331
Braque, Georges 306, 307
Breton, André 338, 340
British 18th-century painting 178
Bronzino (Angelo de Cosimo) 120
Brücke, Die (The Bridge) 300
Bruegel, Pieter 108
Brueghel, Jan 150
Brunelleschi, Filippo 72, 76
Buddhist art 60, 61
Burne-Jones, Edward 218, 238
Byzantine art 46, 47, 48, 54, 256

Canaletto 174, 175

Caravaggio, Michelangelo Merisi da 134, 135, 136, 144, 242, 243
Carolingian Renaissance 52, 53, 54
Carrà, Carlo 336
Carracci, Annibale 132
Catholicism 130, 132
Cellini, Benvenuto 122
Celtic art 50
ceramics 128
Cézanne, Paul 210, 211, 250, 254, 255, 256, 257
Chagall, Marc 290, 291
chiaroscuro 134, 136
Chinese art 22, 124, 194, 208
Chirico, Giorgio de 336, 337
Christian art 44, 45, 52, 256
Church, Frederic Edwin 224
Classical era 24–42
Cloisonnism 262
CoBrA 358
Cole, Thomas 224
Colour Field 362
colour(s) 228, 274
composition 210
computer art 406
Conceptual art 388
Constable, John 208, 209, 230
Constructivism 322
Cornell, Joseph 366, 367
Corot, Jean-Baptiste-Camille 230, 231
Counter-Reformation 130
Courbet, Gustave 232,

233, 234
Cranach the Elder, Lucas 114
Cubism 304, 306, 310, 326

Dada 332
Dali, Salvador 338, 342
Danube School 110, 114
Daumier, Honoré 232, 234
David, Jacques-Louis 182, 183, 184, 185
Degas, Edgar 180, 222
Delacroix, Eugène 200, 201, 206, 207, 226, 274
Delaunay, Robert 310, 311
Delft School 166, 170
Derain, André 294, 295
Der Blaue Reiter, (The Blue Rider) 302, 318
Dix, Otto 344
Donatello 74, 75, 76
Doughty, Thomas 224
drawing 214
Dubuffet, Jean 358, 366
Duccio di Buoninsegna 68, 69
Duchamp, Marcel 332, 333, 334, 335, 376, 388
Durand, Asher B. 224
Dürer, Albrecht 112, 164, 192, 214, 270
Dutch Golden Age 156, 170, 208, 256
Dutch landscape 160

Egypt, ancient 16–20, 36, 40, 214

El Greco 116, 120
Emin, Tracey 394, *395*
Enlightenment 176–98
Environmental art 384
Epstein, Jacob 314
Ernst, Max 338, *339*, 340
Etruscan art 36, *37*
Expressionism 292, 298, 398

Fabritius, Carel 166
Fauvism 294, 296
Feminist art 394
Flemish Baroque 150
Florence 78, 80, 84
French Académie 118, 216
French Baroque 140
frescoes 24, 40
Freud, Lucian 396
Froud, Sigmund 338, 310
Futurism 308

Gainsborough, Thomas 178
Gallego, Fernando 116
Gates of Paradise 78
Gaudier-Brzeska, Henri 315
Gauguin, Paul 250, 260, *261*, 262, *263*, 266, 272
Gentileschi, Artemisia 132, *133*
Géricault, Théodore 200, 204, *205*
Gérome, Jean-Léon 226, *227*
Ghiberti, Lorenzo 74, 78
Ghirlandaio, Domenico 77, 84
Giambologna 122, *123*
Giorgione 98
Giotto de Bondone 70, 71, 74, 164, 214
Gnoli, Domenico 390, *391*
Gothic art 64, *65*, 66, *67*, 80
Goya, Francisco de 148, 200, 202, *203*
Gozzoli, Benozzo 80

graffiti art 386
Grand Tour 174
Grant, Duncan 312, *313*
Greece, ancient 26–32, 42, 44, 72, 96
Grosz, George 344, *345*
Grünewald, Matthias 114, *115*

Halley, Peter 400
Hamilton, Richard 370, *371*
Hard Edge painting 364
Haring, Keith 386
Harlem Renaissance 354
Hasegawa Tohaku 126
Hellenistic sculpture 34
Hindu art 198
Hirst, Damien 404, *405*
history painting 188
Hockney, David 370, 372
Hogarth, William 158, 178, *179*
Hokusai, Katsushika 190, *191*
Holbein the Younger, Hans 114
Hopper, Edward 282, 348, *349*
Hudson River School 224
human figure 154
Hyperrealism 390

icons 48, *49*
Impressionism 236, 240, 242, 246
Inca civilization 58
Ingres, Jean-Auguste-Dominique 182, 184, 206
installations 402
International Gothic 66, *67*, 80
Internet art 406
Islamic art 56, 196

Japanese art 126, 190, 208, 244
Japonisme 190, 244
Judd, Donald 368, *369*

Kandinsky, Wassily 302, *303*, 316, 318, *319*
Kaprow, Allan 402
Kapoor, Anish 402, *403*
Kinetic art 374, 376
Kirchner, Ernst Ludwig 300, *301*
Klimt, Gustav 278, 280, *281*
Kokoschka, Oskar 292

Land art 384
landscape painting 208
Landseer, Edwin Henry 180
Lawrence, Jacob 354, *355*
Le Brun, Charles 140
Le Corbusier 326
Le Nain brothers 140, 158
Leonardo da Vinci 88, 90, *91*, 136, 148, *155*, 214, *215*
Leyster, Judith 151
Lichtenstein, Roy 370, 372
light 242
Limbourg Brothers 66
Lindisfarne Gospels 50, *51*
Lion Man of Hohlenstein Stadel 0
Lippi, Fra Filippo 80, *105*
Lorrain, Claude 142

Macke, Auguste 302
Maes, Nicolaes 166
Magritte, René 338, 342, *343*
Malevich, Kazimir 320, *321*
Manet, Édouard 232, 236, *237*, 240
Mannerism 120, 122, 144
Mantegna, Andrea 84
Marc, Franz 180, *299*, 302

Mariscal, Javier *401*
Masaccio *73*, 74
Masson, André 338, 340
Matisse, Henri 226, 274, 294, 296, *297*
Maya 58
Medici, Lorenzo de' 78, 88, 92
Memling, Hans 110
metaphysical painting 336
Mexican art 350
Michelangelo 40, 78, 84, 92, 120
Millais, Everett 218, *219*
Millet, Jean-François 230, 234, *235*
Ming Dynasty 124
Minimalism 378
Minoan art 24, *25*, 40
Miró, Joan 338, 340
Modernism 284
Mondrian, Piet 210, 274, 316, *317*, 324, *325*
Monet, Claude 240, 241, 244, 246, *247*
Morandi, Giorgio 256, 336
Moreau, Gustave 258, *259*
Morris, William 218, 220, 221
mosaics 42, *43*
Mughal art 190, 190
Munch, Edvard 286, *287*
Muralists, Mexican 350
Murillo, Bartolomé 144
Muybridge, Eadweard 222, *223*
Mycenaeans 26
myths and legends 96

Nabis, the 264
naïve art 266
naturalism 34, 70, 80, 214
Nefertiti 20
Neoclassicism 182, 200

Neo-Expressionism 398
Neo-Geo 400
Neo-Impressionism 250
Neo-Plasticism 324
Neue Sachlichkeit 344
Newlyn School 356, *357*
Noland, Kenneth 364, *365*
Northern Renaissance
 102, 214

O'Keeffe, Georgia 328, *329*
Olmecs 58
Op art 374
Orientalism 226
Orphism 310
Ottonian art 54, *55*
Ozenfant, Amédée 326, *327*

Pahari School 198
Paris, School of 290
Parker, Cornelia 402, *403*
Penone, Giuseppe 382, *383*
performance art 378
Perry, Grayson 128
perspective 76, 82, 84
Phidias 32
photography 222, 240
Photorealism 390
Picasso, Pablo 290, 304,
 305, 306
Piero della Francesca 84, *85*
Piombo, Sebastiano del 98
Pissarro, Camille *229*, 244
Pluralism 392
Pointillism 250
Pollock, Jackson 360, *361*, 378
Pontormo, Jacopo 120, *121*
Pop art 370, 392
portable paints 228
portraits 148
Post-Impressionism 250,
 268, 294
Post-Painterly Abstraction
 362

Postmodernism 392
Poussin, Nicolas 142, *143*
Praxiteles 32
Pre-Raphaelite
 Brotherhood 218
Pre-Raphaelitism 238
Pre-Renaissance 68
Precisionism 348
Primitivism 266, 300
printmaking 270
Protestant Reformation
 102, 130
Purism 326

Qing Dynasty 194

Rajastjani painting 198
Ramses II 20
Raphael 94, *95*, 149
Rayonism 310
Realism 232, 234, 284,
 348, 352
red-figure pottery 30, *31*
Regionalism 348
Rembrandt 136, 157, 162,
 163, 164, 271
Renaissance 40, 68–118, 148
Renoir, Auguste 248, *249*
Reynolds, Sir Joshua 178
Ribera, José de *137*, 144
Riemenschneider, Tilman 110
Rivera, Diego 350, *351*
Rococo 136, 172
Rodchenko, Alexander 376
Rodin, Auguste 248, *249*
Roman art 38, *39*, 42, 72
Romanesque art 62, *63*
Romanticism 200
Rossetti, Dante Gabriel 218
Rothko, Mark 362, 363
Rousseau, Henri 266, *267*
Rousseau, Theodore 230
Rubens, Peter Paul 150,
 152, *153*, 154

Ruskin, John 218, 220

sacra conversazione 82
St Ives School 356
Sánchez-Cotán, Juan 144
Schiele, Egon 292, *293*
Schnabel, Julian 398, *399*
School of London 396
sculpture 186
self-portraits 164
Sérusier, Paul 264, *265*
Sesshu Toyo 126
Seurat, Georges 250,
 252, *253*
Signac, Paul 250, 252
Socialist Realism 352
Space Age Art 358–82
Spanish Golden Age 144–6
Spanish Renaissance 116
Steen, Jan 158, *159*
Steenwyck, Harmen 168,
 169, 256
Stella, Frank 368
Stijl, De (The Style) 324
still life 256
Stone Age art 8–10, *9*, *11*
Stubbs, George 178, 180
Sumerian art 12
Suprematism 320
Surrealism 338, 342, 360
Symbolism 258
Synthetism 260, 262, 266

Tatlin, Vladimir 322, *323*
tempera 104
tenebrism 136, 144
Tiepolo 174
Tinguely, Jean 376, *377*
Tintoretto 120
Titian 98, 100, *101*, *189*
Tjapaltjarri, Clifford
 Possum 380, *381*
Toulouse-Lautrec, Henri de
 250, 268, *269*

*Très Riches Heures du Duc
 de Berry* 66
Turner, J.M.W. *193*, 208, 212,
 213, 242, 274
Tutankhamun 20

Ukiyo-e 190, 244, 270

van der Weyden, Rogier
 102, *103*, 108
van Dyck, Anthony 150
van Eyck, Jan 106, *107*, 164
Van Gogh, Vincent 164, *165*,
 210, 244, *245*, 250, *251*,
 272, *273*
van Ruisdael, Jacob van
 160, *161*
vanitas 168
Vasarely, Victor 374, *375*
Velázquez 144, *145*, 146, *147*
Venetian School 98
Venice 174
Venus figurines 8, *9*
Vermeer, Johannes *167*,
 170, *171*
Veronese, Paolo 98, *99*
Verrocchio, Andrea del 84
Vienna Secession 278
Viking art 50
Vorticism 314
Vouet, Simon 140, *141*

Warhol, Andy 370, 372, *373*
watercolour 192
Watteau, Jean-Antoine 172
Wen Zhengming 124, *125*
Whistler, James McNeill
 238, *239*, 244
Wright, Joseph 178

YBAs (Young British
 Artists) 404

Zurbarán, Francisco de 144